For Walter and Ruth,
memories of out door India!
Our thanks and love,
Josh and Sally
December 2004

Josh Alcorn
2004

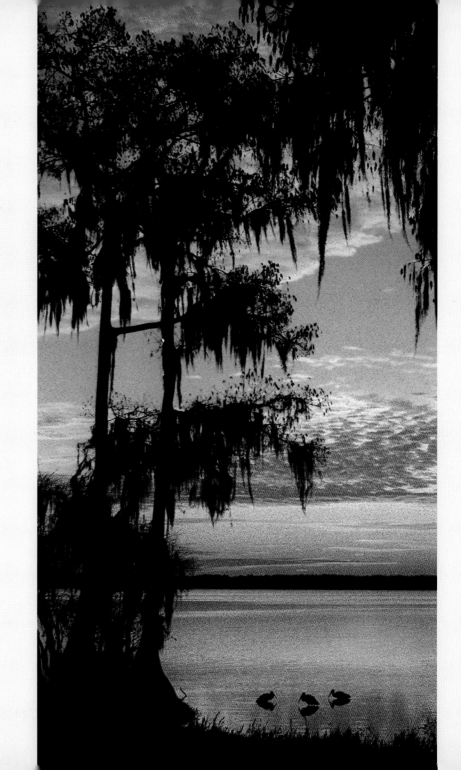

University Press of Florida · State University System

Florida A&M University, Tallahassee
Florida Atlantic University, Boca Raton
Florida Gulf Coast University, Ft. Myers
Florida International University, Miami
Florida State University, Tallahassee
University of Central Florida, Orlando
University of Florida, Gainesville
University of North Florida, Jacksonville
University of South Florida, Tampa
University of West Florida, Pensacola

John Moran

University Press of Florida

Gainesville

Tallahassee

Tampa

Boca Raton

Pensacola

Orlando

Miami

Jacksonville

Ft. Myers

JOURNAL OF LIGHT

The Visual Diary of a Florida Nature Photographer

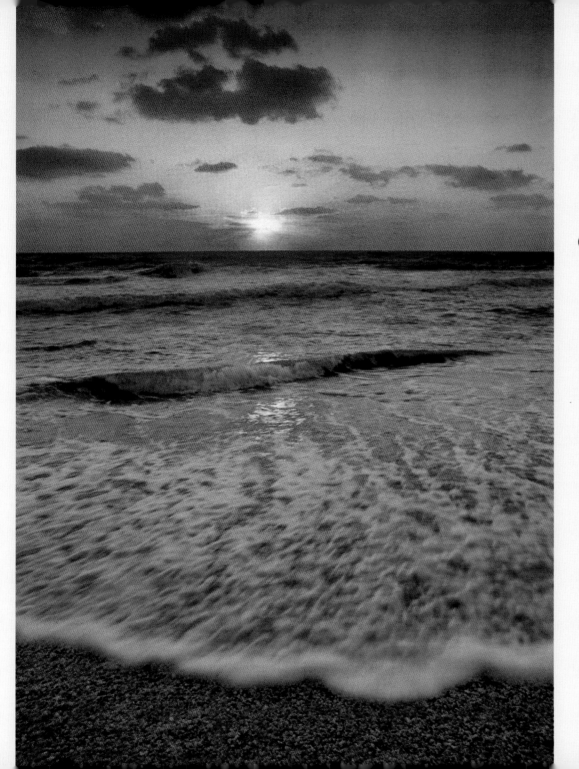

*T*HE story of Florida is written in water.
When the oceans receded from what one day
would come to be known as Florida,

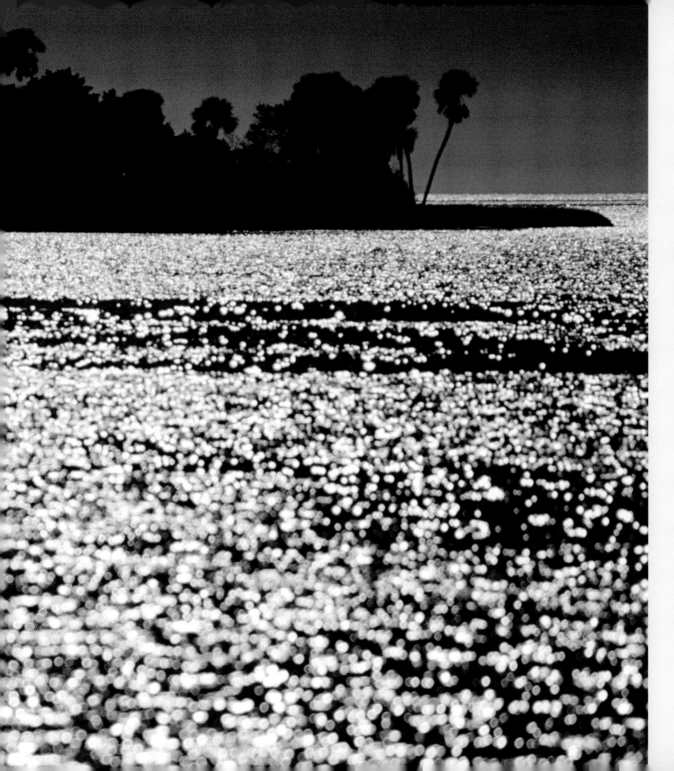

*the peninsula we call home
emerged, surrounded by warm seas*

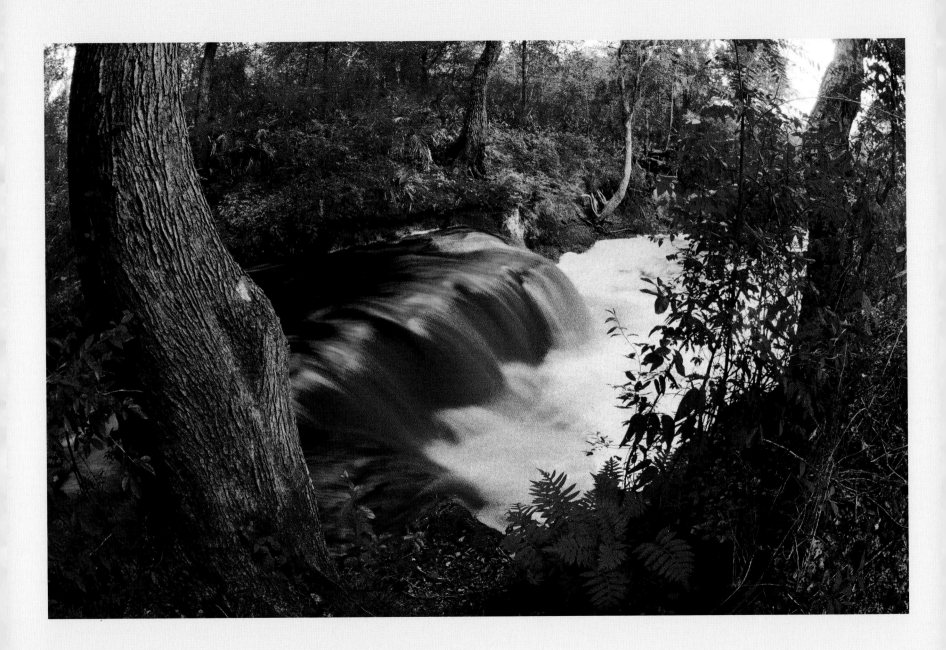

and blessed with an abundance
of rivers and lakes and springs.

A profusion of flora and fauna soon followed;

a wealth of trees
and flowers and birds

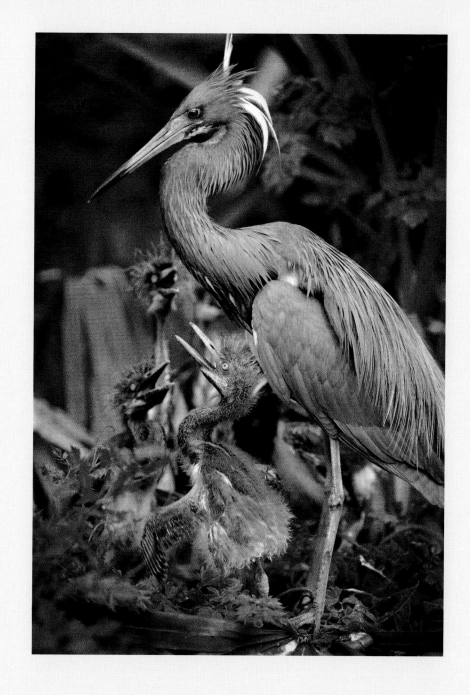

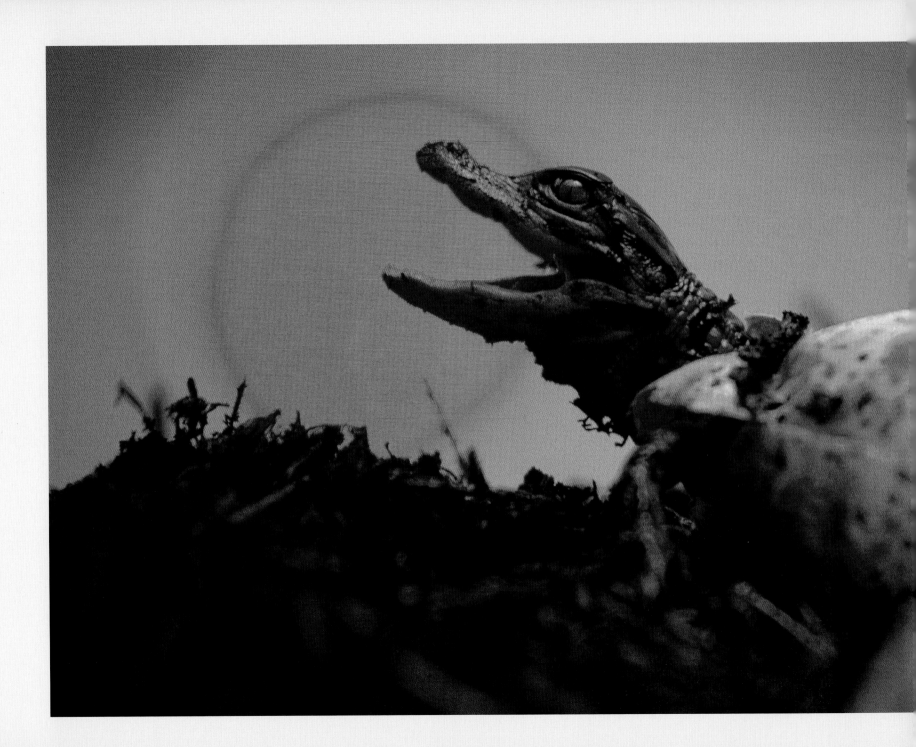

and reptiles,

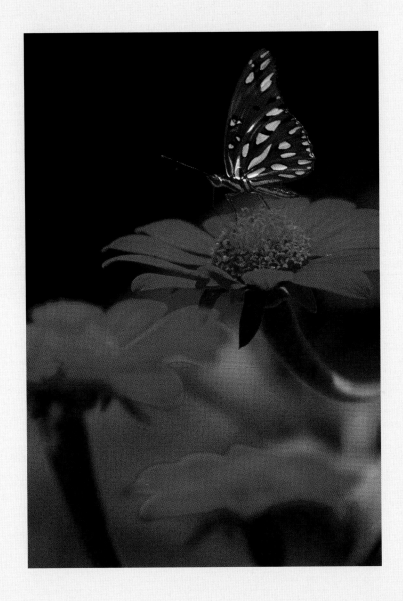

and a unique landscape of beauty
beyond measure took form.
Could the Garden of Eden
have been more enchanting?

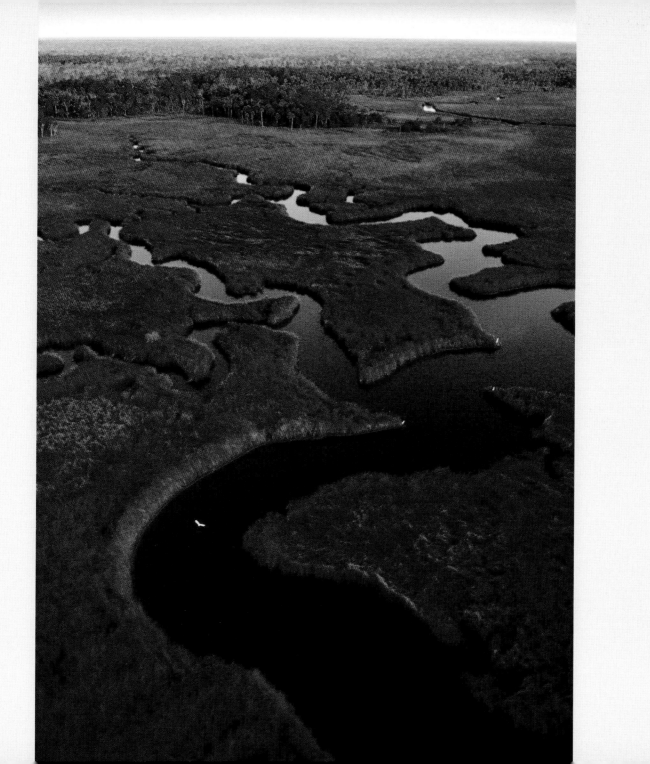

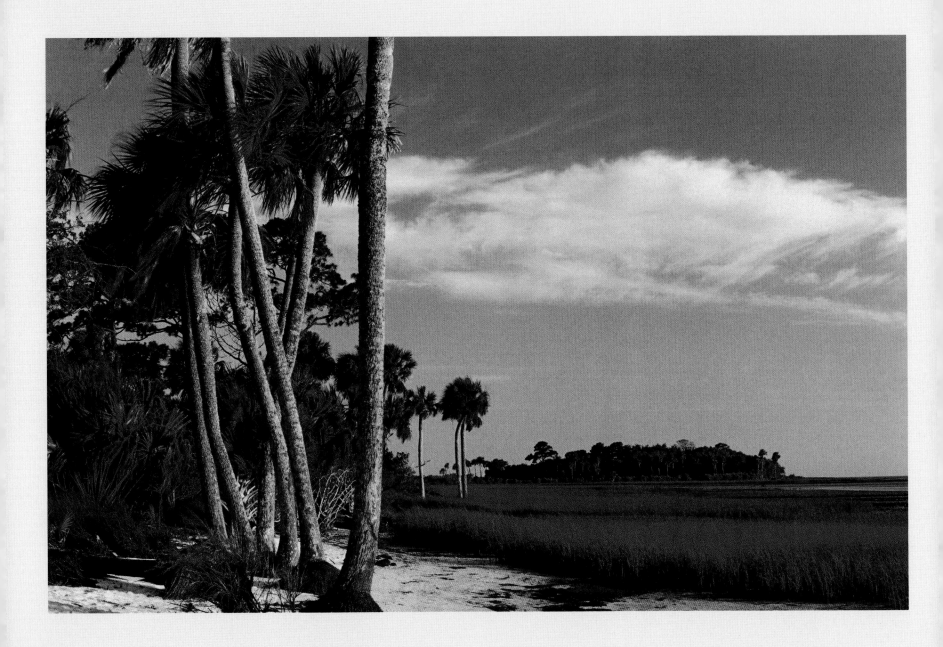

*B*Y an accident of fate, I landed in this veritable paradise, arriving as a transplant in diapers when Eisenhower was president. Falling in love with the world out my back door was the involuntary response of a child who knew only comfort building tree houses and boats in orange groves and cypress swamps. Photography came later, after the bond with the geography of my childhood was secure.

I want to tell you about my love affair with Florida. It's said that writing is easier when you have something to say, and yet, I struggle still to find the words. Fortunately, when words fail, pictures speak; and photography has become the language in which I best express my deep gratitude for the gift of calling Florida home.

Aah, Florida. Discovered and celebrated, developed and consumed; her soul can yet be found by those with wonder in their hearts. This, then, is my Florida journal, scripted in light for a land born of water. My home.

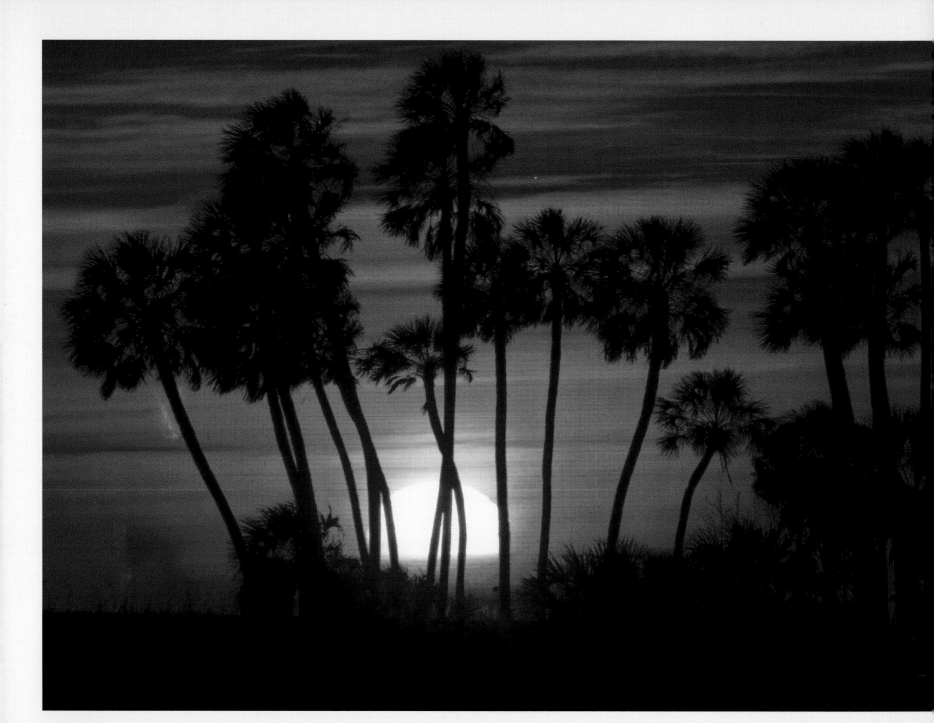

JOURNAL OF LIGHT

Magic in the Glades

Rainbow at Sunset, Big Cypress National Preserve, Collier County, 2003

I finally made it to the Everglades for my first shooting trip at age forty-seven. I had to quit my day job as a newspaper photographer to make it happen, finally realizing that Florida's a big state, and I was never going to photograph all of it if I had to be back at work every Monday morning until I turned sixty-five. And so between art festival weekends in Coconut Grove and Naples, I spent the week in the Glades, cycling past herons and egrets on Shark Valley Loop Road, dodging alligators in my kayak on the Turner River, slogging between royal palms and bald cypresses in Fakahatchee Strand.

What an eye-opener, this photographic homecoming. I grew up in Fort Myers and have longed for many years to return to the South Florida landscape of my childhood with my cameras, my *Florida Atlas and Gazetteer*, and my expanded sense of life's possibilities as an adult. North-to-south, Florida is one state, but many worlds, and this trip was long overdue.

Driving west on Tamiami Trail, a late-afternoon thunderstorm is thrashing Big Cypress National Preserve. The sun breaks, and begets my first Everglades rainbow. It's a beauty all right, bright and saturated, and I instantly begin looking for foreground I can work with. Two miles of useless beauty rolls by, and after the longest two minutes of my week, I spy a perfect little cluster of palms in the distance and pull onto the shoulder of Highway 41. My car-and-trailer rig tightly pinched between the guardrail on the right and the pavement on the left, I consciously avoid looking back at the onrushing traffic.

"I'm willing to die for this picture," I tell myself, and I grab my camera and tripod and climb to the roof of my SUV. It's pretty crowded up there, and the only place for me to set up is to stand in the open cockpit of my kayak. Road wind from passing tractor trailers and motor homes buffets my perch as I compose the rainbow arcing from the palms. I shoot half a roll of film before the rainbow fades, as they inevitably must.

In the post-photo afterglow, I just stand there looking, motionless and reflective. OK, so this wasn't the picture to die for after all; but still, not bad. . . and then, late for the party, a flock of egrets flies through the scene, all white against the purple sky; the weakened rainbow powerless to rival this unexpected gift.

Reflexively, I shoot this picture too, offering myself the same bittersweet counsel I've handed countless amateur photographers; that nature photography isn't always about the picture, it's about the experience of just being there, chasing the light, alive and awake and aware.

The photograph was made with a 70–300mm zoom lens on Fujichrome Velvia slide film.

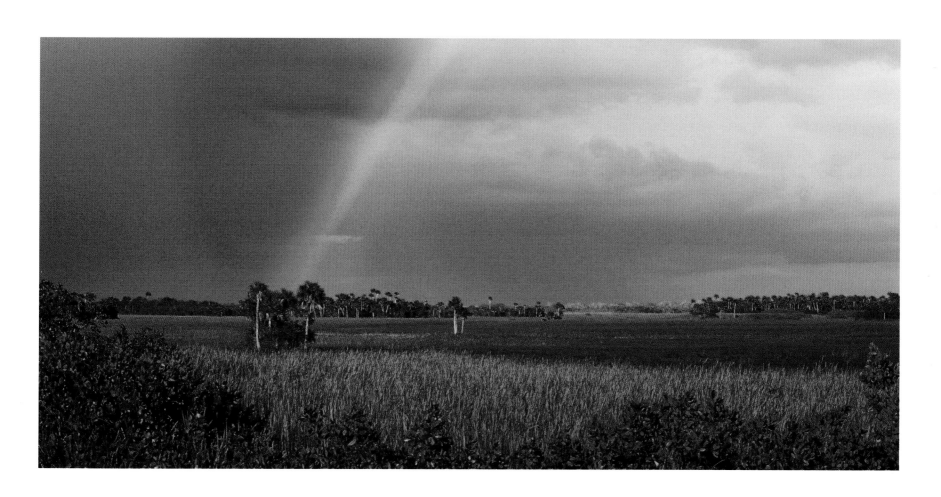

A Wish for Posterity

Polar Smoke at Ginnie Springs, Santa Fe River, Gilchrist County, 1997

Imagine for a moment the Florida of our forebears, the land of *La Florida* explored by Juan Ponce de Leon in his fabled search for the Fountain of Youth. Imagine the lush sights that greeted Hernando de Soto, seeker of gold, and Pedro Menendez de Aviles, founder of St. Augustine.

With limited tools and limitless resolve, these early strangers in Paradise pushed forth into the interior wilderness of the peninsula in what surely was a remarkable odyssey of discovery.

I often wonder what Florida must have looked like four hundred years ago. It's a mind-set that serves me well as I compose my nature photographs, absorbed in a viewfinder fantasy, imagining myself as the first European explorer ever to see, say, the beauty of North Central Florida's Ginnie Springs by the light of sunrise.

Fantasy, of course, is the operative word here. As I pull back from the viewfinder, reminders of modern life are evident in abundance. Ginnie Springs is there in all its splendor. But one of Florida's loveliest springs shares the landscape with a bathhouse, picnic pavilion, parking lot, street lights, signs, steps, decks, and the other amenities that modern people seem to need for their treks into nature.

Like many natural attractions in Florida, Ginnie Springs is well managed. But if it's real wilderness I seek, I'll have to search deeper. Wilderness is nearly a forgotten concept in Florida, and so, like the species displaced by development, I have learned to adapt.

I have adapted by creating pictures that suggest the illusion of wilderness. Carefully composing my photos, I seek a Florida without power lines and clear cuts, unblemished by billboards and litter. I have made many of my best nature pictures literally within sight of my car, aware of my own impact upon the land, mindful of the myth of untainted nature I promote with my camera.

Despite an astonishing assault on the aesthetic and ecological integrity of Florida, ours is a state yet rich in the abundant gifts of nature. My wish, my fantasy, really, is simply that we Floridians muster the will to preserve for posterity a state whose remaining natural gifts are sustained forever.

The photograph was made with a 24mm lens on Fujichrome Velvia slide film.

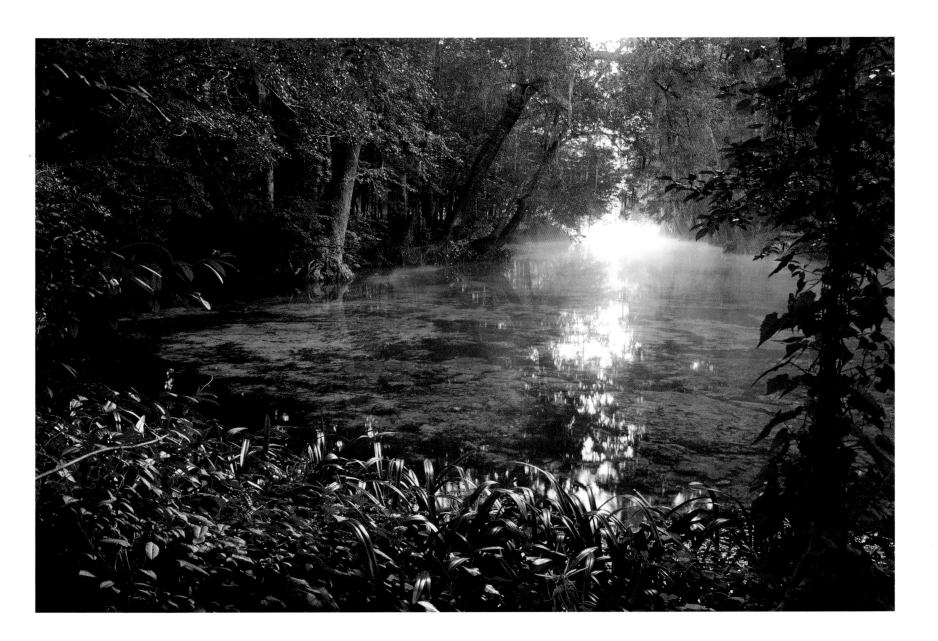

A Stage for the Big Sky

Twin Palms/High Water, Paynes Prairie Preserve State Park,
Alachua County, 1997

I met an unhappy University of Florida graduate student several years ago. His studies were going well, but he was miserable in Gainesville and he was going home to Saudi Arabia. The trees finally got to him.

He was OK with Florida's summer heat. The humidity and the insects he could handle. What prompted him to pack his bags was a sense of claustrophobia induced by the tree canopy of North Central Florida. He longed to return to a place where the trees wouldn't get in the way of the sky.

Despite a hundred years of development, much of Gainesville remains truly a city in the trees, a fact made notable every time I fly low and slow over town to make aerial pictures of our urban landscape. There are, of course, places in the interior of Florida where you can admire the view of afternoon storm clouds building up with few trees in the way; most shopping center parking lots will do the job. I prefer Paynes Prairie, just south of Gainesville, with its distant sweep of horizon providing a verdant stage for the "big sky."

Landscape photographer Clyde Butcher, hailed as the Ansel Adams of the Everglades, says there seems to be a line across the state at about Tampa Bay separating North and South Florida into distinct zones of dissimilar conditions for cloud formation. While South Florida often has gorgeous neotropical skies, the summer sky over Gainesville on many days is mired in a stifling haze, devoid of drama. But there are days every summer that just call out to be photographed.

Leaving work late one day, I headed south out of town on U.S. Highway 441. Through the trees, I could see cumulonimbus thunderheads punctuating the sapphire sky. Racing across Paynes Prairie, the tree canopy receded and the clouds went on forever. Standing side by side in the golden light, twin sabal palms seemed to insist that I make a U-turn to take their picture. (I don't recommend the use of this line, incidentally, if you're interrupted by a trooper while making pictures on the right-of-way.) Glass-smooth high water, a reminder of record winter rainfalls, provided a compositional mirror on which to make a picture unlike any other I've made on the prairie. Once again, great light on great subject matter made simple my task.

The photograph was made with a 24mm lens on Fujichrome Velvia slide film, using a Nikon A-2 warming filter and a 2-stop graduated neutral-density filter.

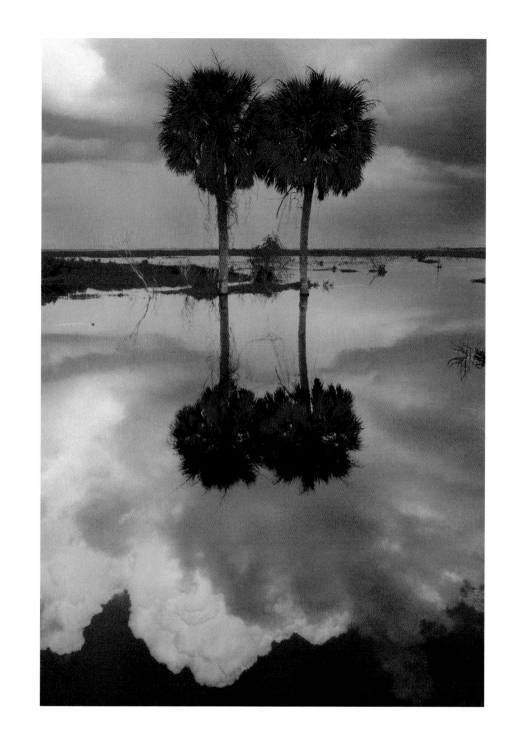

Beneath a Rainbow Spring

Peninsula Cooter, Rainbow Springs State Park, Marion County, 1996

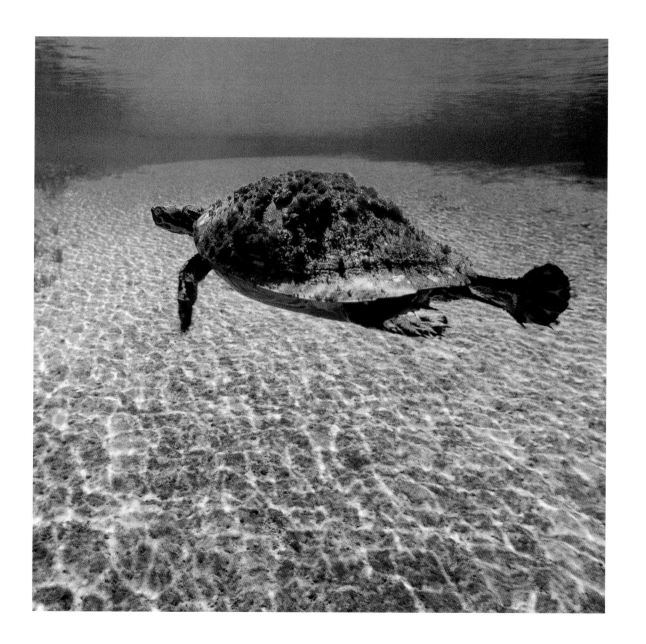

Stealing Beauty

Sunrise Sentinel, Newnan's Lake, Alachua County, 1993

A noted art professor once said, "Good artists borrow ideas. Great artists steal them."

And so it was with larceny in my heart that I went to Newnan's Lake on the summer morning I made this picture. I'm no stranger to the primordial beauty of the lake. For many years, I've appreciated that such a lovely waterscape just five miles from downtown Gainesville has escaped the intense development that has changed the face of so many lakes elsewhere in Florida.

The lake's twelve-mile shoreline is broken only occasionally by a handful of houses, a few docks, and two public boat ramps. What Newnan's Lake has in abundance are cypress trees, alligators, and an impressive array of wading birds. Here, the memory of Old Florida is easily conjured.

The lake has inspired some of my best work over the years. And yet on this day it was the work of another photographer that had inspired my sunrise photo outing to the fishing pier at a county park on the lake's south shore. Just weeks earlier I had photographed on assignment a location portrait of Lucinda Kidd Hackney at this spot. Lucinda had recently won first place in the *Sierra* annual nature photography contest with a picture she had made from the pier, and the *Gainesville Sun* scheduled a feature story on her and her prize-winning photo.

Lucinda's photo is a Florida classic. Bathed in the warmth of sunrise light, an alligator has crawled onto a log, its tail curling gently into the dark lake. The backdrop is defined by bald cypresses, festooned with Spanish moss swaying in the morning breeze. The scene is timeless and compelling.

There is value in humility, and that's the feeling I had when I picked up *Sierra* and first saw her photo. I'd never made a picture by sweet light from the pier at Powers Park, and I made a mental note to act on the inspiration to do so.

A couple of weeks later, I got up early and drove two miles to the park, hoping to find the gator on the log. The alligator had other plans, I suppose, and it was nowhere to be seen. But a great blue heron was perched on a branch of a nearby cypress, artfully posed as if to say, "Take *my* picture!" And so I did, and I was back home before 7:30 a.m.

The picture went into my files, where it languished for a couple of years until I came across it as I prepared a submission of photos for the National Audubon Society in consideration for their new *Field Guide to Florida*. The editors chose five of my pictures for the book, including this one for the cover.

Perhaps because this simple and subtle photo was so easily made, it had never become a personal favorite. No need for a boat or specialized equipment. No subject or location research. No access or logistical problems. No reshoots, and just two miles from home. The heron on the branch was ducks in a bucket, as they say.

I suspect that readers and editors care little if it's difficult for a photographer to get the shot. They don't want to hear about the labor, they just want to see the baby. As it should be: it's the picture that counts.

The photograph was made on Fujichrome Velvia slide film with a 300mm lens and a Nikon A-2 warming filter.

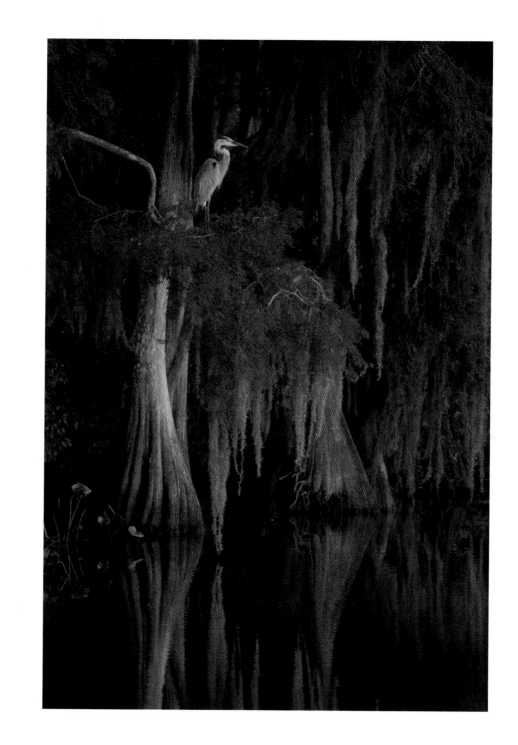

The Night Has a Thousand Eyes

Alligators at Dusk, Paynes Prairie Preserve State Park, Alachua County, 1990

It's a subtle picture, really. There are others in my collection that I like better. But this monochromatic picture of alligators at dusk has become the signature image of my Florida portfolio. People are fascinated with animals that can eat you in the dark, and this picture speaks to that primal fear.

I'd been trying for years to make a good picture of alligators at Paynes Prairie, which is perhaps the finest natural alligator observation area in America. I had often heard about great concentrations of gators at Alachua Sink, on the prairie's north rim. But every time I went searching with my cameras in hand, I found maybe a couple dozen gators at most, spread over a wide area.

Seeking a picture with a different look, I opted for a nighttime visit to the prairie. Alligators are sun worshippers by day, but they're more active when the day fades to night; feeding, courting, bellowing, and piercing the darkness with their powerful night vision. And so I arrived at Alachua Sink on a Sunday in May, alone on the prairie basin, on a bluff overlooking the water. I set up my camera on a tripod as night settled in.

Hoping to catch their eyeshine, I turned on my AA-battery Maglite and slowly scanned the scene before me. With the modest flashlight beam, I was amazed to count not dozens, but hundreds of pairs of eyes shining back at me; 212 pairs in all. After a year and a half of drought, most of the prairie's wetlands had dried up, forcing the alligators to congregate in this remaining deep pool. A wide-angle picture would lack the visual cues needed to recognize four hundred points of light as alligator eyes, so I opted for a short telephoto lens and keyed in on the big gator in the foreground. With him as a reference point, the nature of those forty-three pairs of light-points becomes apparent.

The picture exposure was thirty seconds on Fujichrome slide film, with low-power electronic flash illuminating the alligator eyes. The combination of electronic flash and a long time exposure recorded the reflective light of eyeshine and the ambient light of deep dusk. I returned a week later, hoping to improve upon the picture. But the number and distribution of the alligators wasn't nearly as impressive.

I've long enjoyed hearing the animated responses of people as they see this photo for the first time and comprehend the many points of light. As I travel the art show circuit throughout Florida, I love to tell the story of how I made the picture. Was I scared to be alone with all those alligators? Nah, I tell them. Alligators are like investment bankers; they're looking for maximum return on minimum investment. Why would those gators bother to climb a ten-foot embankment to take out a photographer when they could much more easily eat a turtle or a fish or one of their own young?

With a sly grin, I tell prospective customers that if they take the picture home with them, they can tell their friends they were the photographer's assistant, swatting away the gators with a canoe paddle as I set up to make the picture.

The photograph has been published in dozens of books and magazines worldwide, including *Life*, *Fortune*, *Natural History*, and the Audubon engagement calendar. It was the top-placing American photograph at the United Nations 1992 Earth Summit photo contest. Countless prints of the photo adorn home and office walls around the world. Those hard-working, globe-trotting reptiles even helped to pay for my daughters to attend the University of Florida. Go Gators!

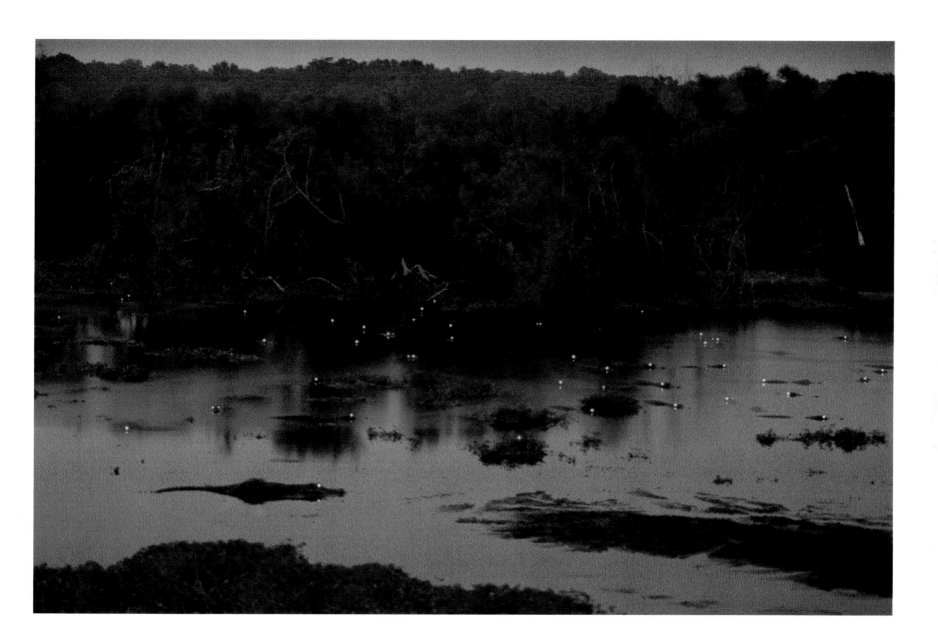

Status: Endangered; Future: Uncertain

Wood Storks, Myakka River, Sarasota County, 2003

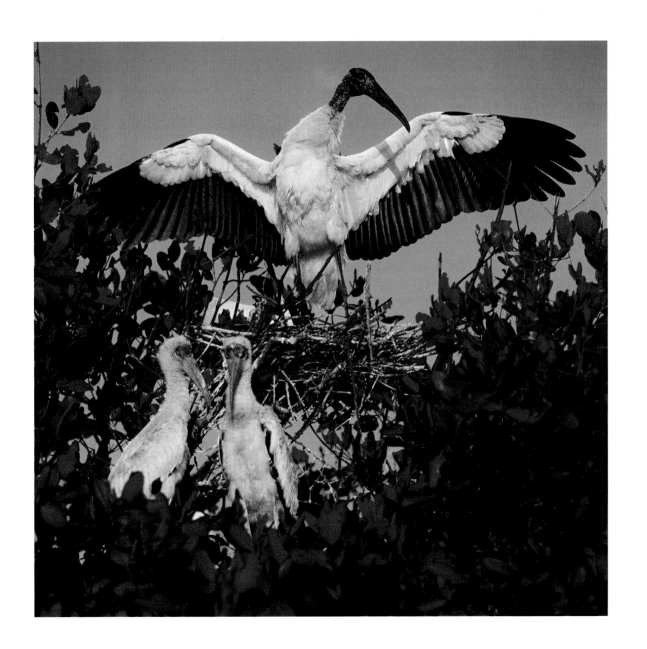

Accept This Gift

Coreopsis Heaven, Putnam County, 2000

My friend Trude sent me an invitation by e-mail . . .

"You must see our coreopsis heaven," she wrote, "a thick, golden carpet laced with pecan trees. The flowers will be peaking in the next week . . ."

Who could resist such an offer?

Over the course of twenty-plus years, I've amassed a collection of pictures that bear the imprint of countless people who have guided, taught, inspired, and otherwise compelled me to be in the right place at the right time to photograph the nature of Florida.

But for all the pictures I've made that represent opportunities seized, I'm struck with the remembrance of invitations declined and opportunities lost. In many ways, our lives are a series of gifts accepted, and gifts rejected.

As in any field of endeavor, talent will only get you so far in photography. The impediments to great nature photography are many, and most have nothing to do with ability. The fading of the light and the passing of the seasons care little for my laundry list of reasons for all the great pictures I've missed because I responded late or not at all.

Given the demands of life beyond the camera, it's impossible to know about, much less respond to, all the wonderful nature photo opportunities awaiting those who will simply seek and find them. And so I have come to rely on photo tips from friends and strangers, suggestions that have enriched my life by forcing me to drop everything, and seize the opportunity to immerse myself in the natural world.

I can't respond to every suggestion, and often when I do, the tips yield nothing of publishable value. It's a given that most outings yield pictures that can be described as ordinary at best. The light is too contrasty, or too flat. The background is lousy. The flowers peaked a week ago. My "vision" feels cramped today. What was that person thinking when they suggested I come here?

But it would be pointless and counterproductive to focus negatively on this seemingly haphazard process. There are moments of transcendent beauty that await us, if we just say yes and accept the invitation.

The photograph was made with a 24mm lens on Fujichrome Velvia slide film. I used a Nikon A-2 light amber filter to accentuate the color of the sun and the flowers, and a 3-stop graduated neutral density filter to darken the sky. A lens aperture of f/22 yielded the starburst effect as the sun reached the horizon.

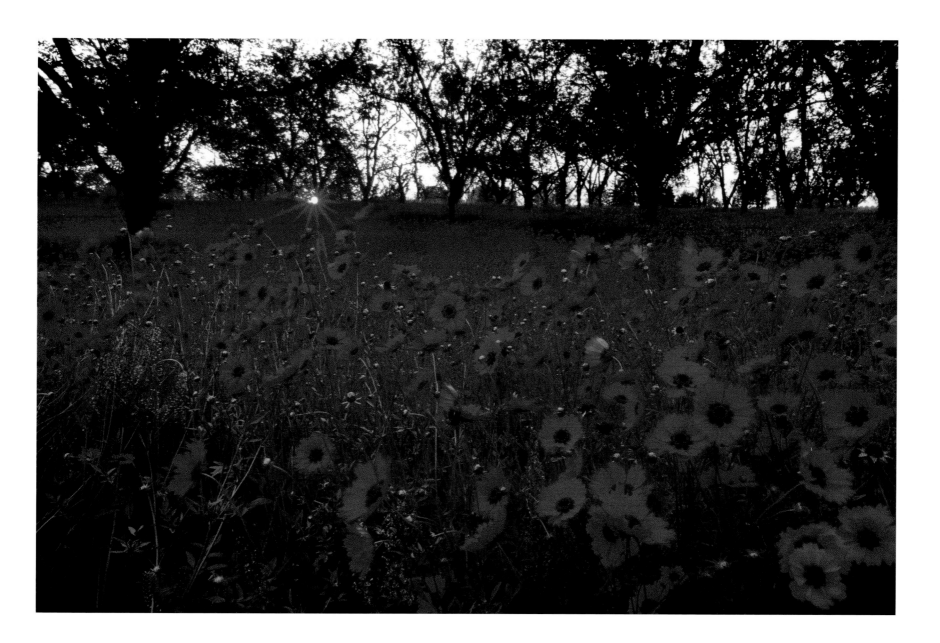

The World Is a Miraculous Place

Comet Hale-Bopp, Mathews Farm, Levy County, 1997

Of all the interests we have in childhood, it's hard to know which we will carry forth into adulthood. Though astronomy was my earliest passion in life, I was soon to learn that math is the language of science and that my love for the night sky would not sustain a career in astronomy. But I discovered photography at about that time and was soon happily bumbling my way through some really awful nighttime pictures. The seeds were sown.

I cannot recall all the pictures I've made that reflect my early interest in astronomy, but I do recall vividly a picture I didn't make, a beautiful picture of Comet Hyakutake that was published nationwide in 1996. Distributed by the Associated Press, the photo, by Johnny Horne of the Fayetteville, North Carolina, *Observer-Times*, showed the comet drifting past the Big Dipper. I was impressed by its clarity and aesthetics, and I felt humbled by my lack of preparation to make a photo of this caliber. But the world of astronomy was already abuzz with the approach of Comet Hale-Bopp, and I resolved not to let the Big One get away. I had a year to prepare . . .

I wanted to make a picture of the comet that not only was beautiful, but clearly grounded in the landscape of Florida. Among the many impressive natural features of this place we call home, live oaks—dead or alive—hold particular allure. I had just the right tree in mind for my picture. For a hundred years and counting, comets, eclipses, meteors, and more have added drama to the night sky beneath which this ancient live oak has borne silent witness.

Deep-sky photography typically involves long time exposures with precisely guided instruments that track the apparent movement of the stars through the night sky. I consulted University of Florida professor Alex Smith, with whom I had taken an introductory astronomy course twenty years earlier. He showed me a simple but effective tracking device he had made to photograph the return of Halley's Comet in 1986. I built my own, based on his design.

Called a barn-door tracker, the gizmo consists of a pair of 1 x 4 boards joined with a hinge that is aligned to turn on axis with the rotation of the Earth. The rig is anchored to a tripod and the camera is mounted on a ballhead attached to the top board. I replaced the hinge pin with a brass tube for sighting on the North Star, and by manually turning at 1 rpm a $^1/_4$-20 thumbscrew offset 11 $^7/_{16}$" from the hinge pivot, the boards spread, moving the camera, slowly . . .

The world is a miraculous place, and it was a beautiful experience sitting alone in the dark in the middle of nowhere with my little comet tracker, hand-cranking my camera in silent synchronicity with the universe.

The photograph was made with a Nikon FE2 camera and 35mm lens on Fuji Super G 800 film. The exposure was 5 minutes at f/2.8. The tracking motion, while "freezing" the stars (and comet), creates a ghostly blur in the oak tree and the distant tree line. Radio-triggered strobes with amber gels cross-illuminate the tree. Two and a half minutes into the exposure, while continuing to turn the hand crank at 1 rpm, I slipped a Nikon soft-focus filter onto the lens, causing the stars to visibly glow around their central points of light.

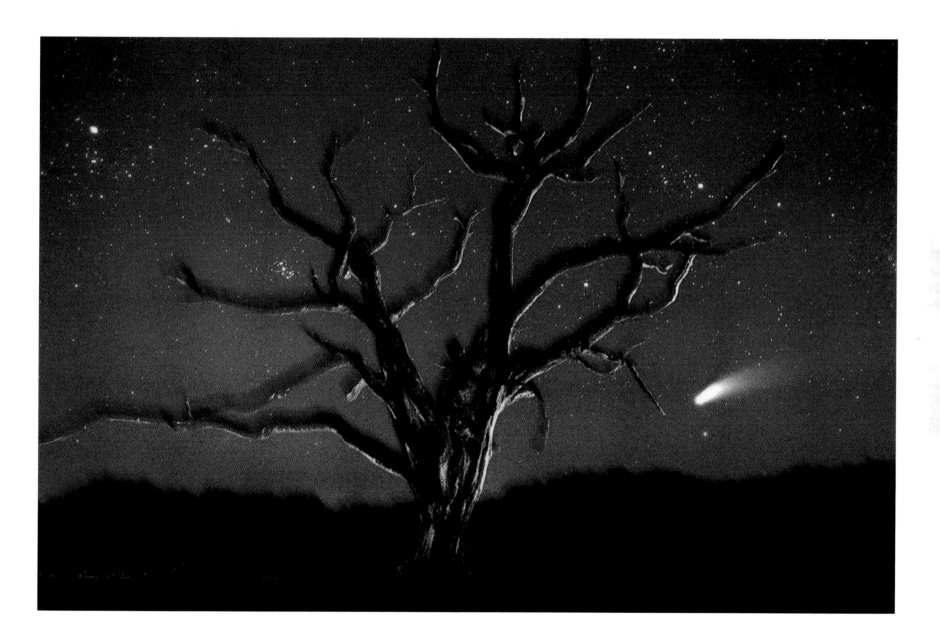

The Secret Beach

Lower Suwannee National Wildlife Refuge, Dixie County, 1990

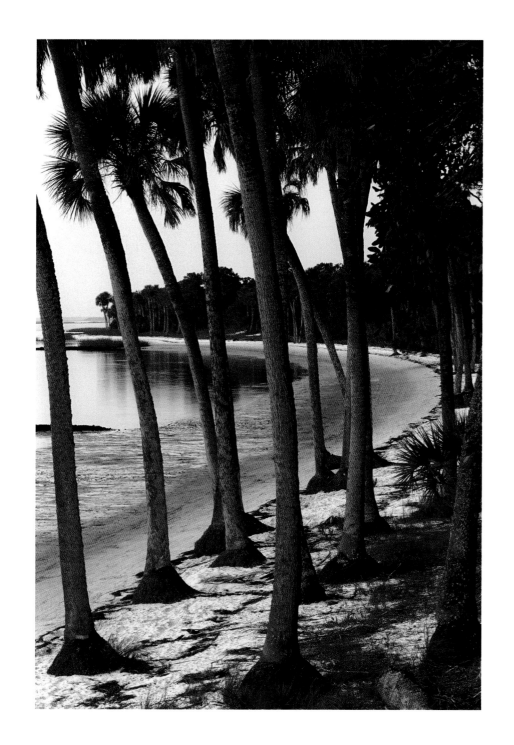

The Debate Behind the Lens

Swamp Dragons, St. Augustine Alligator Farm, 1997

A proliferation of television programs and wildlife magazines routinely brings us images of animals that startle us with their drama and intimacy. Posters and T-shirts, books and calendars attest to the impact of the wildlife photographer's art. There's no debating the quality of the pictures, but there is a debate behind the lens. An essay in *Double-Take* magazine argued for a moratorium on wildlife photography, asserting that photographers are harming wildlife and habitat in their quest for ever more dramatic pictures.

Writer Bill McKibben suggested there are already enough photographs of animals in stock files and that new pictures are unnecessary. He also called for strict rules on creating new wildlife photos in the future. Several magazines, including *Harper's*, *Audubon* and *U.S. News and World Report*, subsequently published articles exploring the controversial practices of some wildlife photographers.

Kent Vliet, coordinator of labs for the University of Florida biological sciences program, has an opinion of his own about the matter. Featured in the 1986 *National Geographic* television special, "Realm of the Alligator," Vliet literally found himself up to his armpits in alligators as he waded among the big gators of the St. Augustine Alligator Farm to study their courtship behavior, earning a Ph.D. in the process. A big guy with a disarming comfort in handling gators, Vliet has worked with all the major providers of wildlife film, including the Discovery Channel, PBS (for *Nova*), and the BBC.

"There's simply not the time or the money to stand around and wait for these natural events to occur, so wildlife filmmakers must create artificially for the camera those situations that do occur in nature, but are too fleeting or rare to capture well on film," Vliet says.

Vliet says that while there doubtless are abuses, he has found a high level of self-imposed ethical standards to be common in the wildlife photography community.

"Most go to great lengths to verify that what they are depicting on film actually represents natural events," he says.

Which brings us back to the St. Augustine Alligator Farm. For years, I've seen pictures of baby alligators basking atop their mothers, using her back or head as a convenient platform to get out of the water. With deadline approaching for a book on alligators I was photographing, I enlisted Vliet's assistance in setting up this picture. It was "Hollywood Goes to the Swamp," with lighting diffusers, reflectors, light stands, and an assortment of camera gear scattered about a makeshift set behind the scenes at the Alligator Farm, where Vliet straddled an eight-foot mama gator and gently positioned the hatchling gator on her head.

"The public is simply unaware of all that is entailed in getting these shots," Vliet says. "If it's a good picture, you forget that there's a photographer there, just like if it's a good actor, you forget that they're acting."

The photograph was made with a 300mm lens on Fujichrome Sensia slide film.

Hi Sally
John

John Moran
Photography

■

www.johnmoranphoto.com
email:
johnmoran@mindspring.com

1327 SE 69th Way
Gainesville, FL 32641
352.373.9718

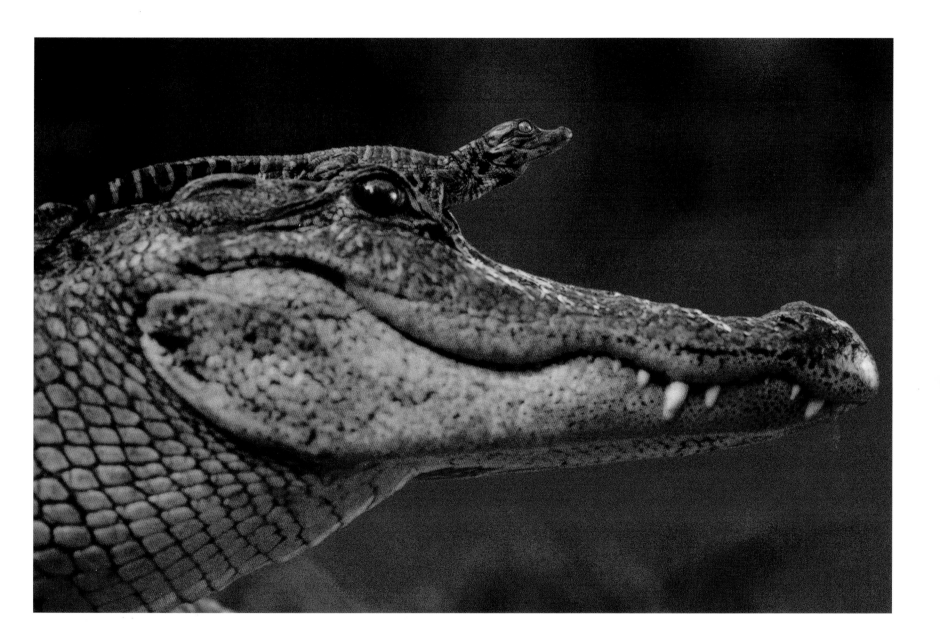

Venus Kisses the Moon

Newnan's Lake, Alachua County, 1995

If you're a runner, perhaps you can relate. I used to be a marathoner. Ran every day. Age and injury finally caught up; prematurely, I might argue, and the older I get, the better I was.

So there I was, up before dawn, lacing my shoes for another run in the dark, when I spied through the trees a very cool sight in the predawn sky. Venus and the crescent moon were really, really close together. Separated by less than a third of a degree of arc. I pay attention to this stuff; I have done so ever since I was a kid. I just make it my business to know where the moon's been lately, and whose house Venus is in.

I woke my daughters, Alexis and Caitlin, to show them this incredible celestial scene, and then trotted off down the driveway toward Lakeshore Drive and Newnan's Lake. On cue, they both hollered after me, something to the effect of, "Dad! Stop!! What are ya, nuts? You can run later. Go make a picture!"

And so I did. Making a U-turn in the driveway, I returned to the house for my cameras and drove the quarter-mile to a neighbor's dock.

My problem with photographing the night sky is that I want to bring the moon and the planets down to Earth, using a wide-angle lens to provide recognizable foreground and compositional interest. But wide-angle lenses, useful for shooting foreground, make distant objects look really small. To illustrate, consider the detail picture published here, made with a 24mm lens, showing Venus and the moon as I saw them on my initial approach to the lake. The moon looks tiny, an effect not just of camera optics, but also of the perceptual tricks our mind likes to play.

Try this simple test: Hold your hand at arm's length in front of your face, palm out. Go ahead. See how small the fingernail is on your little finger? Surprisingly, your little pinky is actually rather huge, much bigger than even the full moon. Try it outside at night sometime; you can easily eclipse the full moon with just the tip of your little finger at arm's length.

So I decided to make a double-exposure—two pictures on a single frame of film—in order to magnify the impact of the scene in the eastern sky. There's nothing in the laws of photography that says you can't change lenses between the two pictures in a double-exposure.

A band of yellow crept over the horizon as I composed the initial picture of the lake and the distant horizon with a 24mm wide-angle lens. Venus and the moon hovered slightly above my picture, just out of sight in my viewfinder.

Using 800 speed color print film, I shot the first picture, and then using my camera's multiple-exposure function, I cocked the shutter without advancing the film and switched to a 500mm telephoto lens to make the second picture of just the moon and Venus, seconds later. I never actually saw the resulting picture in my viewfinder; just in my mind's eye, and again when I developed the film.

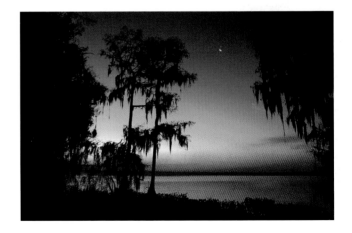

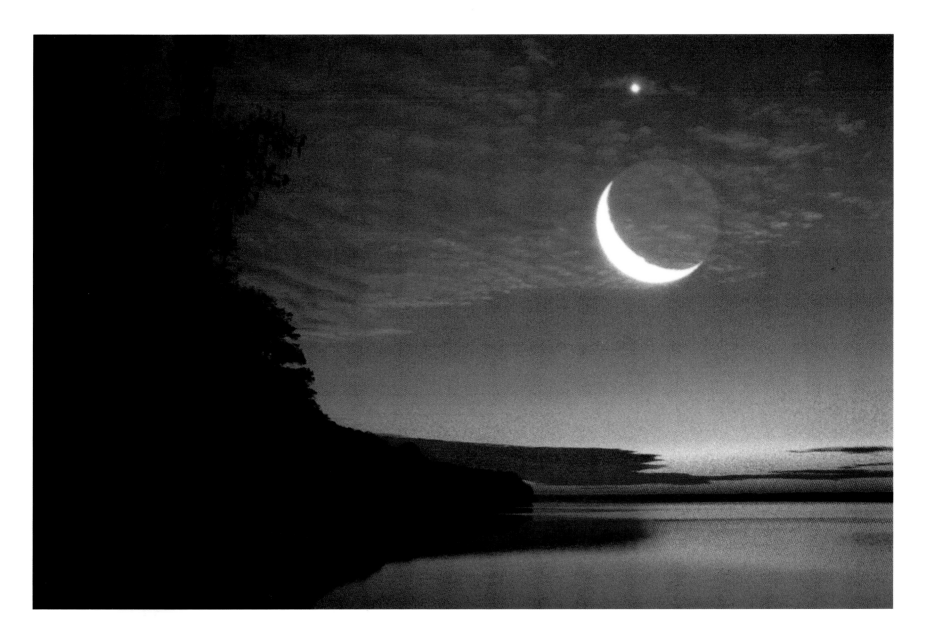

Birds of a Feather

Royal Terns, Indian River Lagoon, Volusia County, 2003

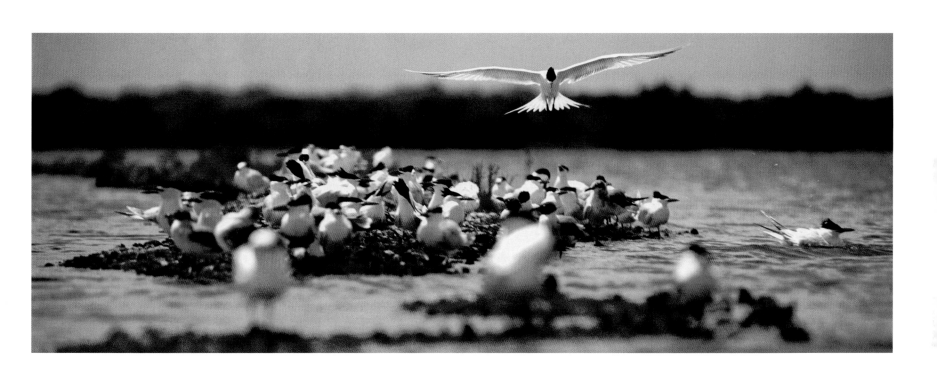

Finding Focus on the Prairie

American Lotus, Paynes Prairie Preserve State Park, Alachua County, 1999

At seventy miles per hour, Paynes Prairie rushes by in a two-minute blur of green.

For two miles, without so much as a billboard to give cover or distraction, the naked prairie has only itself to attract the attention of a ceaseless stream of travelers, many of whom will ordinarily notice nothing of its charms. In the summer of 1999, however, even the jaded traveler could apprehend that something special had enlivened the prairie.

A year after the highest water levels in decades, receding water levels on Paynes Prairie yielded conditions ideal for an unusually profuse blossoming of American lotuses. Between Interstate 75 and U.S. 441, tens of thousands of the spectacular ten-inch flowers arose in unison to create a brightly colored mosaic on the land.

In the week before my visit to see the flowers, half a dozen people sought me out to urge me to go to the prairie with my cameras. Finally I arrive, and I'm not disappointed. Diving in, I'm awash in a sea of yellow and green, adrift in countless acres of impossible beauty. Where to begin my task of making pictures? I pause, and recall advice received years ago. *Before you focus your camera, you must first focus yourself.*

I switch to a close-up lens on my camera and become visually intimate with a single lotus blossom, standing inches away from its sweetly scented ring of undulating stamens, punctuated by a large, conical pistil. It's all so sexual, right out here in front of God and all those tourists bound for Orlando. I'm reminded of Carolus Linnaeus, the eighteenth-century Swedish naturalist acknowledged as the father of modern botany, who observed that, "The genitalia of plants we regard with delight; of animals with abomination; and of ourselves with strange thoughts."

The picture looks great in the viewfinder. A perfect summer sky smiles down on a thousand perfect flowers. But I've seen this picture a hundred times before, and on this day I'm looking for something a little different. *It's time to refocus.*

Something crawls across my sandaled foot and is gone. What, I wonder, does this flower show look like to the critters down there in the muck of the prairie? Soon I'm on my belly, crawling through a damp forest of spongy lotus stalks and spent flower petals.

Three feet overhead, a canopy of circular leaves shades my aimless wander. Finding an opening, I roll onto my back, and settle into the warm, fecund mud of Paynes Prairie. Gazing skyward, I reach for my camera and marvel at the snail's-eye view of the world that comes into focus.

The photograph was made with a 16mm full-frame fisheye lens on Fujichrome Velvia slide film. An aperture of f/22 provided extreme depth of field and also produced a 14-point starburst pattern to the sun. A flexible silver fabric reflector provided fill-sunlight to the underside of the flower.

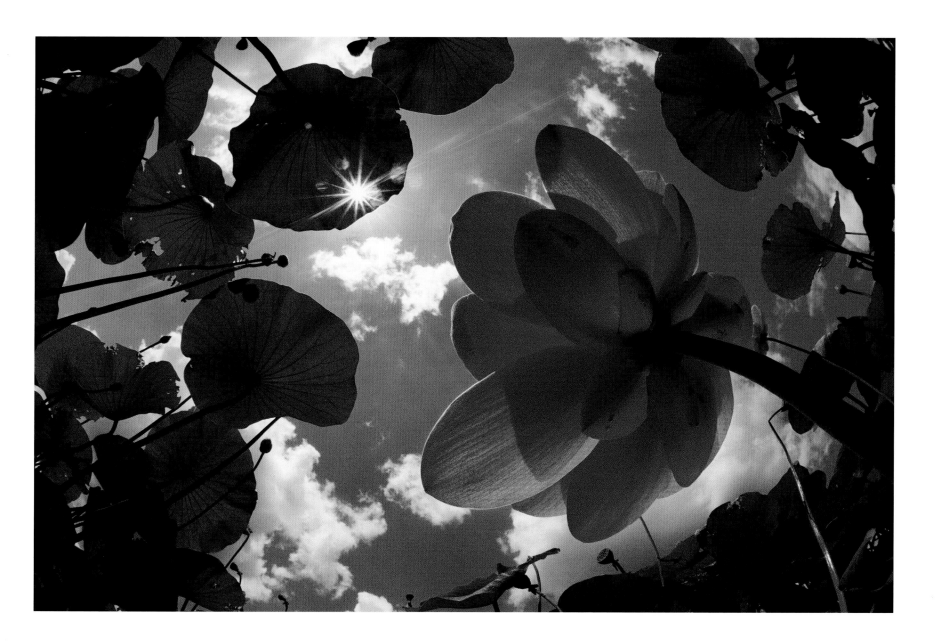

In the Graveyard of Giants

Big Talbot Island State Park, Duval County, 2001

Like a string of sand-laden pearls, Florida's barrier islands descend down the Atlantic and back up the Gulf coast, softening the blow of maritime storms on the mainland's 1,200-mile coastline. Most barrier islands were formed during a relatively rapid rise in sea level at the end of the last ice age, about 10,000 years ago, and their evolution continues today.

Wind and sea are relentless agents of change, and few barrier islands in Florida show their toll more starkly than Black Rock Beach at Big Talbot Island State Park, twenty miles northeast of downtown Jacksonville.

Shifting and changing, the inexorable march of water and sand has left here in its wake a graveyard of giants. Wandering the beach before sunrise, evidence of an angry sea is manifest in the huge old live oaks that litter the beach, their lifeless branches forming a tangle of towering driftwood-in-the-making.

With dozens of dead trees behind me, I choose to photograph the only tree wholly in the water and wait for a distant sea fog to lift, revealing the morning sun. It's a fine scene. This mighty oak, whose ancestors were prized hundreds of years ago by colonial shipbuilders, fought the good fight to defend Big Talbot, and waits now in death for the sea to take it away.

The photograph was made with an 18mm lens on Fujichrome Velvia slide film. A 3-stop graduated neutral density filter darkens the sky to balance the exposure density with the foreground.

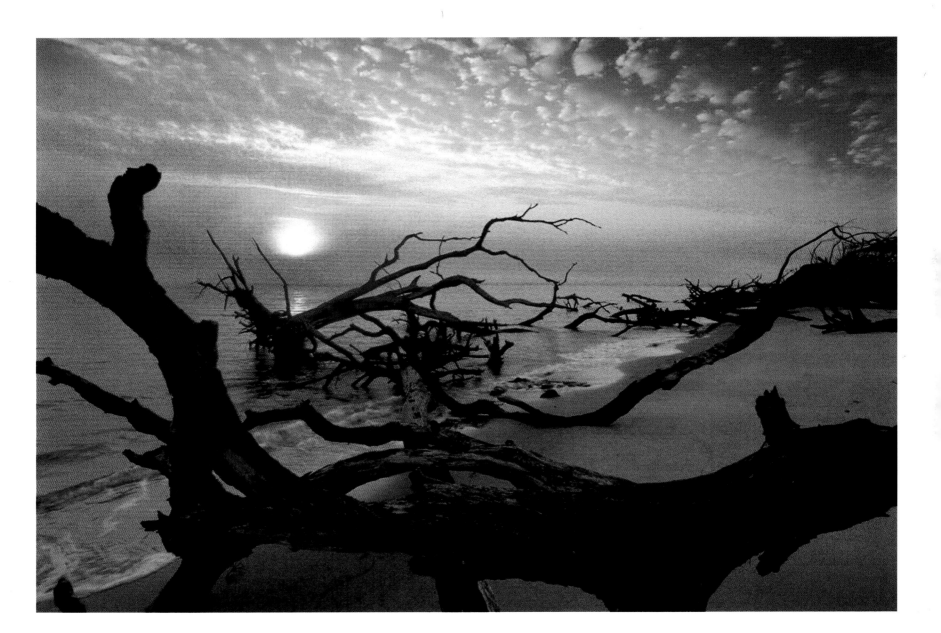

A Haven for Fish

Striped Bass, Silver Glen Springs, Ocala National Forest, Marion County, 1990

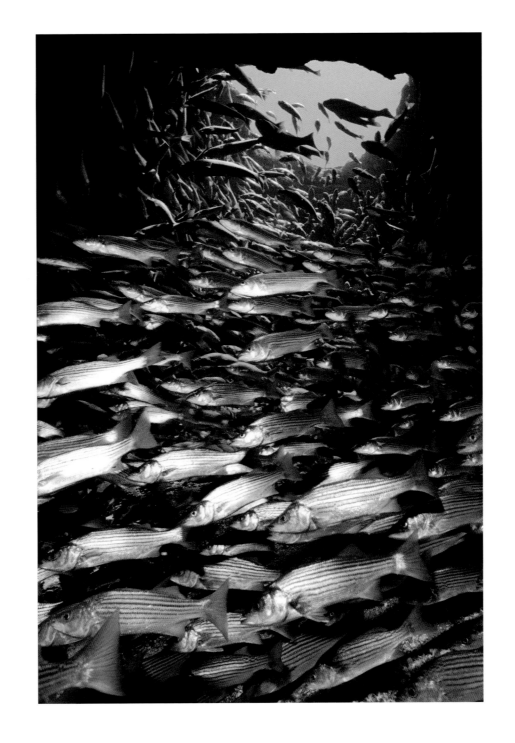

Invisible Man

Suwannee Cooters, Hornsby Springs Run, Santa Fe River, Alachua County, 1989

I'd been trying for several years to make a good picture of these fine old cooters basking on a weathered cypress log at Hornsby Springs Run on the Santa Fe River. If you've spent any time paddling Florida rivers, you know the challenge. As long as you keep moving, the turtles will ordinarily ignore you. Slow down to make a picture and the turtles hit the water, pronto. There are times when you just want to be invisible.

I tried several variations, both shooting from the canoe and approaching on foot through the woods. I even borrowed a 1,200mm super-telephoto lens from Nikon Professional Services to shoot downstream from a couple of hundred yards away. My pictures were merely OK, and I knew I'd have to step it up a notch if I was to be successful.

Still, the frustration was moderated by the joy of the hunt and the time spent in the company of these wonderful creatures on canoe outings to Camp Kulaqua, a Seventh-Day Adventist Church camp. Hornsby Springs Run is a primal slice of Florida that feels like a cross between the Okefenokee Swamp and the Ichetucknee River, with a cathedral of huge cypresses shading the clear spring run to the Santa Fe. With my mask and snorkel, I'd slip out of the canoe to give chase to the cooters underwater. I'd often find them hiding in the eelgrass and grab one by the sides of its huge carapace. It was fine family fun, and hopefully not too stressful on the turtles to gently lay a big turtle on the floor of the canoe and enjoy the spirited reaction of my daughters. Given a choice, I could find happiness being a Suwannee cooter in my next life.

On one paddling trip to my favorite turtle log, I tried a different approach. The turtles scattered as if on cue, while I scouted around for a hefty slab of old cypress wood to take home with me. I drilled a three-inch diameter hole near the end of the misshapen piece of wood, and the following week I returned to the log at Hornsby Springs. Predictably, the turtles scooted and I propped up my slab of predrilled cypress on the edge of the spring run by the log. I clamped my camera to the back of the wood slab, and focused on the bare turtle log, with only the lens visible through the hole. I then attached a radio-triggered remote control to the camera and paddled back upstream, had lunch, and waited.

One by one the turtles climbed back up on the log and when I could see through my binoculars that they were ready for their portrait, I triggered the camera with the remote control from two hundred yards away. Thirty-six times I hit the button, and every picture on the roll of film is identical. Look in the foreground and you'll see the swirling of the duckweed on the water during the one-second exposure. The turtles never knew and never moved. Would that I could always be such a fly on the wall.

The photograph was made with a 50mm lens on Fujichrome RDP 100 slide film.

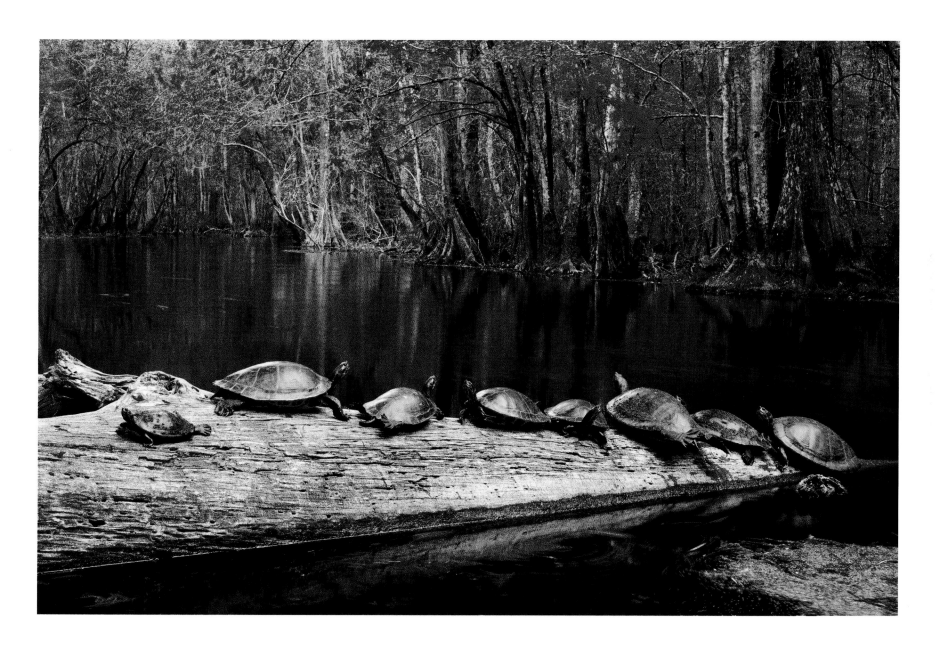

In Praise of Florida's Mountains

Cumulonimbus Thunderhead, North Captiva Island, Lee County, 1995

Answering a call I never heard, my brothers left Florida many years ago to resettle in Portland and Seattle. Ask them what they miss most about their childhood home and the drama of the Florida sky is near the top of the list.

My brothers remember fondly the billowy cumulus and cumulonimbus clouds that on many afternoons would climb to a height that could rival the signature peaks of Mount Hood and Mount Rainier that rise within sight of their West Coast transplant homes.

Aah, but we've got mountains of our own, I say. "Florida's mountains" aptly describes those towering clouds that add such drama to our famously hot and humid summers.

Considered the twin villains that inspired the birth of air conditioning, heat and moisture are also the twin fuels that give rise to the summertime cycle of cloud formation and precipitation that sustains a state dependent on rain, and lots of it.

Clouds form from water that has evaporated from rivers and lakes and the Gulf and the Atlantic and from moist soil and plants. Convective currents, caused by solar radiation, carry this water vapor skyward where it cools and condenses into the cumulus clouds that typify our summer sky.

Often they develop into cumulonimbus clouds with their characteristic anvil-shaped tops. Laden with moisture, cumulonimbus clouds can grow literally to stratospheric heights of 70,000 feet or more. As the cloud pushes into the upper atmosphere, the stable stratosphere resists this invasion from below, pushing down and flattening the cloud top in the process. Violent storms often ensue.

As I photographed this spectacular thunderhead, I thought about how it looked less like Mount Hood than Mount St. Helens—an airborne eruption over the Lee County coast. It could be the most impressive cloud I have ever seen.

Some say that Florida is a state lacking in dramatic grandeur, comparing poorly to the American West. To this I say you have to know where to look, and when. In the summertime, I look to the sky.

The photograph was made with a 35mm lens on Fujichrome Velvia slide film.

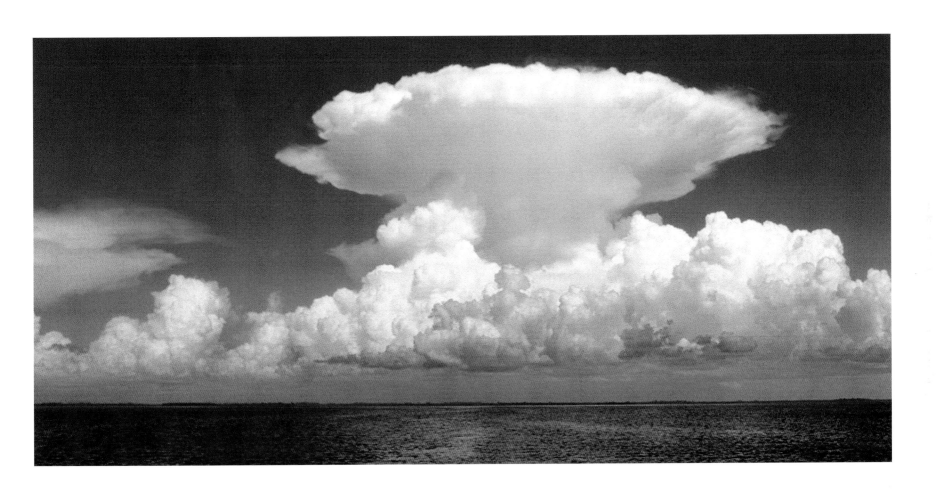

Journey of an Ancient River

Hillsborough River State Park, Hillsborough County, 1987

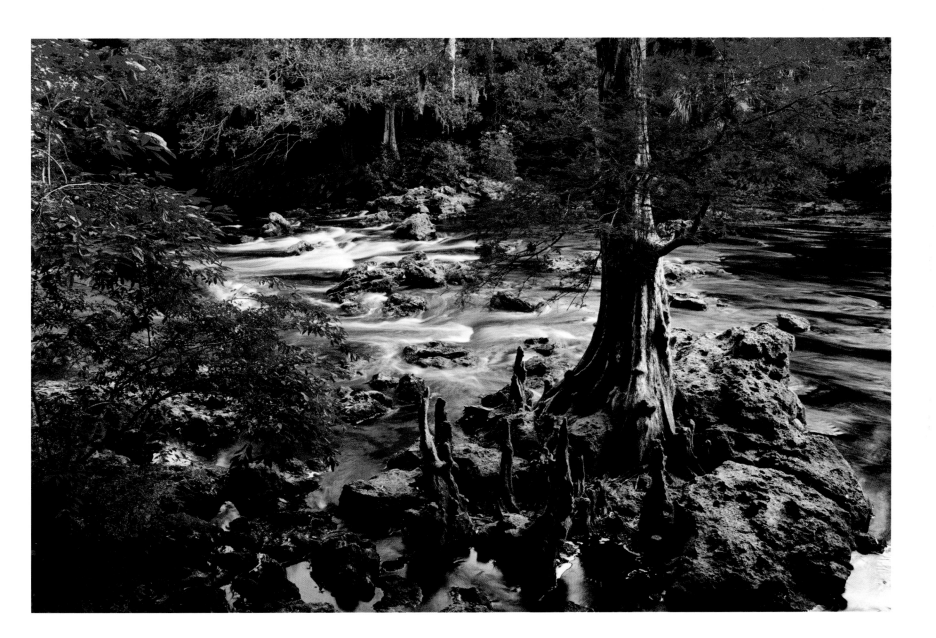

Living Where the Sky Meets the Water

Ospreys at Cedar Key, 1987

Photography certainly isn't brain surgery, and some of my best pictures, while logistically involved, are largely a matter of connecting the dots. This picture is a case in point. The assignment I made for myself in the spring of 1987 was to make a picture with an unusual perspective and a sense of place, showing nesting ospreys at Cedar Key.

So I picked up the phone and called the Central Florida Electric Co-op and arranged for help with my picture from a bucket truck crew on a scheduled service call to the Gulf Coast island community ninety miles north of Tampa.

Ospreys ordinarily prefer pine trees over power poles for nest sites, but they are famously indiscriminate when natural sites are limited or missing. Channel markers, television antennas, radio towers, bridges; it hardly seems to matter to the fish-eating raptors, as long as there's an abundance of fresh seafood nearby. I chose a nest atop a power pole with a broad expanse of water in the background.

When it comes to showing the world from an unusual perspective, a bucket truck is a beautiful thing. Fifty feet above the ground, I looked down into the nest and was greeted by four large osprey chicks, which soon would be ready to fledge. My arrival flushed the parents, and I worked quickly at my task to minimize the intrusion. I clamped a camera with a fisheye lens atop the utility pole and secured a radio-controlled remote trigger to the camera. I then fastened to the utility pole a fiberglass pole reaching above the nest, atop which was attached a convex automotive "objects-are-closer-than-they-appear" mirror.

From ground level, out of sight of the young ospreys, I was able to look with a pair of binoculars straight up the pole into the mirror and observe the birds inside the nest. With my finger on the trigger of the camera's radio remote control, I watched as one of the chicks spread its wings. And with the push of a button my picture was made.

To be sure, making a photograph like this requires a lot of logistics, but the real challenge lies largely in the mind's eye, visualizing it in the first place. Note that I say "making" a picture, as opposed to casually taking a picture. As in baking a cake or doing a tune-up, the job can't be done without a plan and a specific set of tools and materials. Unlike baking or automotive repair, however, there's no guarantee to the results. Which only sweetens the satisfaction when the picture you make is unlike any you've ever seen.

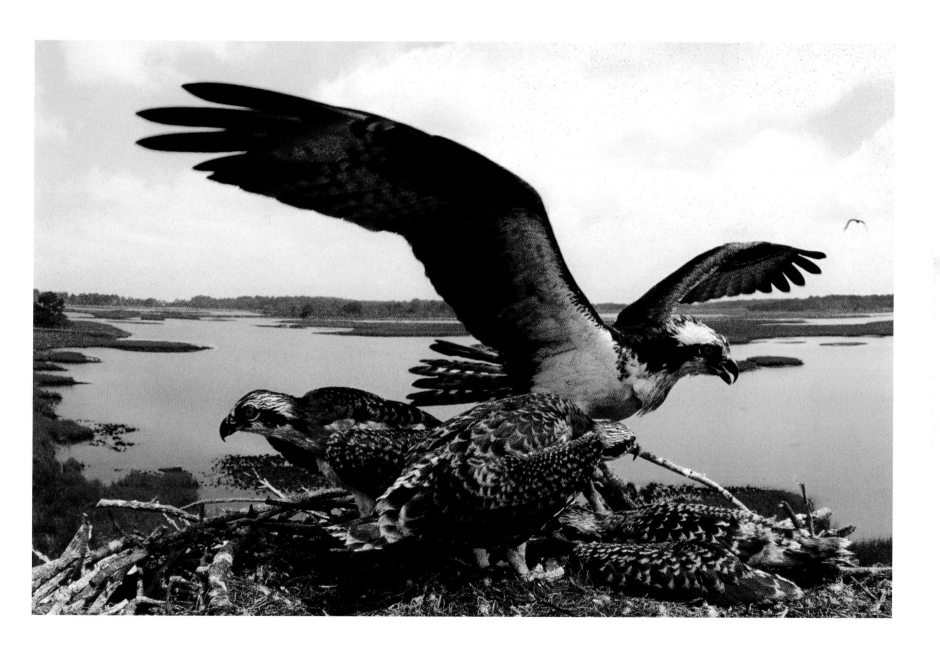

Embraced by the Light

Blue Hole Springs, Ichetucknee Springs State Park, Columbia County, 1995

Thirty feet beneath the surface, I am immersed in another world; deep in the womb of the Ichetucknee.

Nowhere in Florida have I seen light underwater that feels so divinely inspired, if seasonally transient. In October and February, neatly cleaved on the calendar by the winter solstice, the position of the sun yields conditions ideal for the drama you see here. My assignment for my diving partner was simply to play in the light, and to feel its spiritual embrace.

In concordance with the seasons, the sun is wending its way through the calendar, and I am witness to the silent spectacle of changing light on the Ichetucknee. Like the ancient skywatchers who gave us temples of the sun, I've paid attention to the march of the seasons here on the river.

The Ichetucknee is a river of many faces. Every summer, up to three thousand people a day converge on Florida's most popular tubing river, and it's quite a sight to see so many people enjoying their state park. I stay away, preferring instead to go to the river in the quiet of the off-season.

With the close of tubing season on Labor Day weekend, the kids are back at school and their parents are back at work. Tranquility returns to the river, and it's much easier to tune in to the pulsing of the planet. A pair of limpkins bobs for apple snails. An Indian summer breeze shimmers across the surface of the clear water. As though late for lunch, an otter zips beneath my kayak. Even the light feels different in the fall, as well it should.

With the sun calling the tune, the temperature mellows and the maples along the riverbank begin to turn. The call of the cicadas falls silent, and southbound sandhill cranes pass overhead; all connected by the cosmic happenstance of an oscillating planet to the shifting of the light here in Blue Hole. And there are those who say that Florida has no seasons . . .

The photograph was made with a Nikonos underwater camera and a 15mm wide-angle lens on Fuji Super G 800 film.

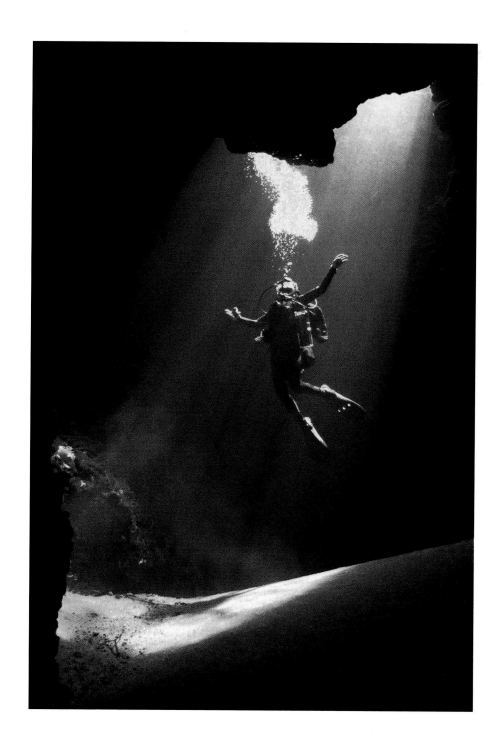

Lost in Time

Loxahatchee River, Jonathan Dickinson State Park, Martin County, 2004

The Lake Alice Experience

Lake Alice, University of Florida, Gainesville, 1998

When I finally had my first "Lake Alice experience," the lake on the University of Florida campus was nowhere in sight. The lovely lake had worked her charms on generations of students, faculty, staff and visitors, and yet I had somehow managed to avoid the seduction.

I got a hint I was missing out on something rather potent when I was assigned to photograph a campus presentation in which a loose-knit coalition dubbed the "Friends of Alice" made a pitch to derail university plans to build high-density housing for about 380 students across the street from the lake.

Those plans to accommodate the housing needs of a growing university met with considerable opposition, and the Friends of Alice joined in filing a formal challenge to the UF master plan, arguing that sites elsewhere on campus were preferable. The issue was scheduled to be decided by the governor and cabinet.

Nine cabinet aides traveled to Gainesville on a fact-finding trip and spent a morning with campus planners and administrators, who made their case for building on the site. Later in the day, the aides sat in the front row of a standing-room-only crowd at the UF law school and listened as a string of seventeen speakers rose to explain how the Lake Alice experience had enhanced their lives.

Several students spoke. One told of how working in the student agricultural garden on the site across from the lake had taught her life lessons about responsibility, patience, failure, and success. She was followed by neighboring residents and faculty members who related with passion and eloquence their views on the aesthetic and environmental costs if the university prevailed with their development plans.

Environmental heavyweight Archie Carr weighed in from the grave by way of his son, David, who read aloud excerpts from a letter the senior Carr wrote in 1969 to then-UF President Stephen O'Connell in opposition to a proposed state road along the lake.

"A part of my motivation in writing this letter comes from recollecting the frequency with which people in distant places have told me of their delight that such a treasure as Lake Alice could exist on the campus of a great university," Carr wrote.

The meeting ended and, as a flaming sunset painted the sky, the cabinet aides walked to the nearby lake and joined a couple of hundred people gathered for the nightly emergence of 60,000 bats, in search of their nightly diet of insects, from a "bat house" situated across from the lake.

I made a picture from across the street and left on deadline with a "record shot" that showed the scene, but conveyed little of the Lake Alice experience that many of these people would carry home in their hearts. I left feeling frustrated that neither my pictures that night, nor any I had ever made, captured on film the sentiments expressed in the testimonials I had just heard.

My second Lake Alice experience came just two days later when I suddenly awoke at 5 a.m. I swear I had a sense that the lake was calling me. I drove across town in the dark, wondering what Lake Alice had to show me. I like to imagine Florida as a wilderness; that's a fantasy, for sure. But it wasn't hard to imagine that the sunrise scene unfolding before me was far, far away from a college campus of more than 40,000 students. Thanks for the wake-up call, Alice.

The photograph was made with a 24mm lens on Fujichrome Velvia slide film.

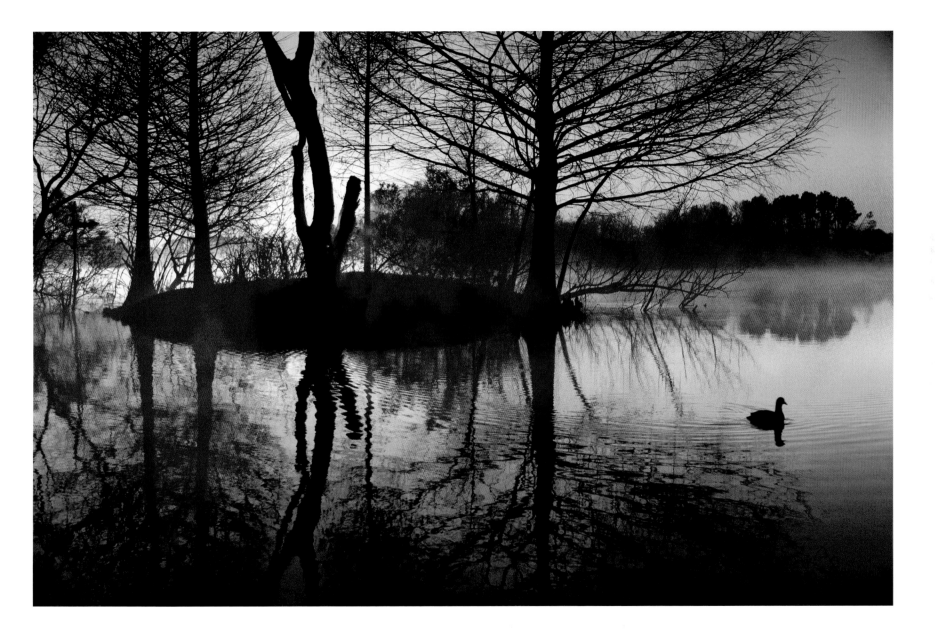

What Were They Thinking?

Dumping at Olustee Creek, Columbia and Union Counties, 2000

Doubtless you didn't expect to see this scene as you thumbed through a book celebrating Florida's natural beauty. Well, it's not all bliss and beauty out there, and my background as a journalist compels me to throw this picture in the mix as a visual reality check.

The beauty of Florida has fed my photographic soul for a quarter-century, but I can't tell you how many times I've had to recompose my pictures to eliminate a beer can or a bed mattress or worse in the woods.

It's been said that how we treat our very young and our very old is a telling indicator of who we are as a society. Add to that how we treat the planet when no one is watching. With Florida's population growing inexorably larger, it's safe to say that there is no "away" when we throw our stuff away.

The tannin-stained waters of Olustee Creek divide Columbia County from Union County as it meanders south to join the Santa Fe River in North Central Florida. In late 2000, I went with canoe guide Lars Andersen to check out a subterranean swallet in the nearly dry creek bed, where creek water flows underground. Parking along a dirt road in the woods, we walked to the one-lane bridge to take in the view. And what a view it was. In order to sanitize a scene for the camera, I'll sometimes remove offending flotsam. But this was no ordinary scene.

Tires, construction scaffolding, a broken toilet, a gutted deer carcass, a stolen newspaper rack; I became photographically fascinated with the wild assortment of garbage in my viewfinder. Photographs tell us much about the world, but I'm left to wonder, *what were these people thinking?*

"They don't care," says Dan Rountree, a guy who has had plenty of time to ponder the point while helping to remove tons of trash from area rivers. "It sickens me, but I know I'm dealing with humanity, so it doesn't amaze me."

Rountree is president of Current Problems Inc., the parent organization of Adopt-A-River, the citizen-activist organization he cofounded in 1992 to spearhead protection and preservation of North Florida waters through litter cleanup and prevention. Rountree says that Adopt-A-River volunteers remove about 30,000 pounds of litter from Gainesville area waters and the Suwannee River watershed each year. Nearly half the garbage retrieved is recycled.

"The person who gets up and leaves his fishing stuff on the bank or tosses his litter over the bridge is the same person who might drain their crankcase oil on the ground," Rountree says.

Like a giant sponge underlying the state, the aquifer is the drinking water source for ninety-three percent of Floridians, Rountree says. Water that flows beneath this bridge ends up in the Floridan Aquifer, captured downstream by the big sink at O'Leno State Park, a sobering thought to consider as you drink in the details of this picture.

Falling water levels during Florida's turn-of-the-century drought revealed scores of ancient canoes in North Florida lakes, providing a fascinating glimpse into a culture that had trod lightly on the land. The drought also revealed a sad snapshot of today's throwaway culture, where the concept of stewardship remains, for some, a stranger in paradise.

The photograph was made with a 24mm lens on Fujichrome Velvia slide film.

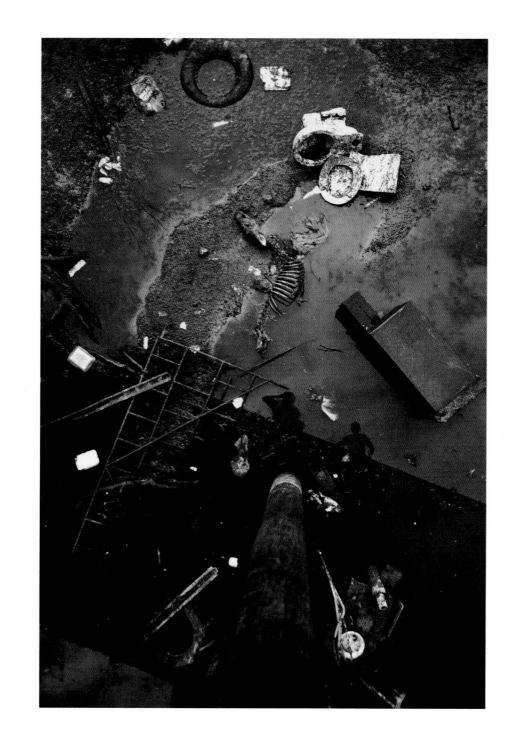

Anchoring the Dunes

Sea Oats at St. Joseph Peninsula State Park, Gulf County, 2003

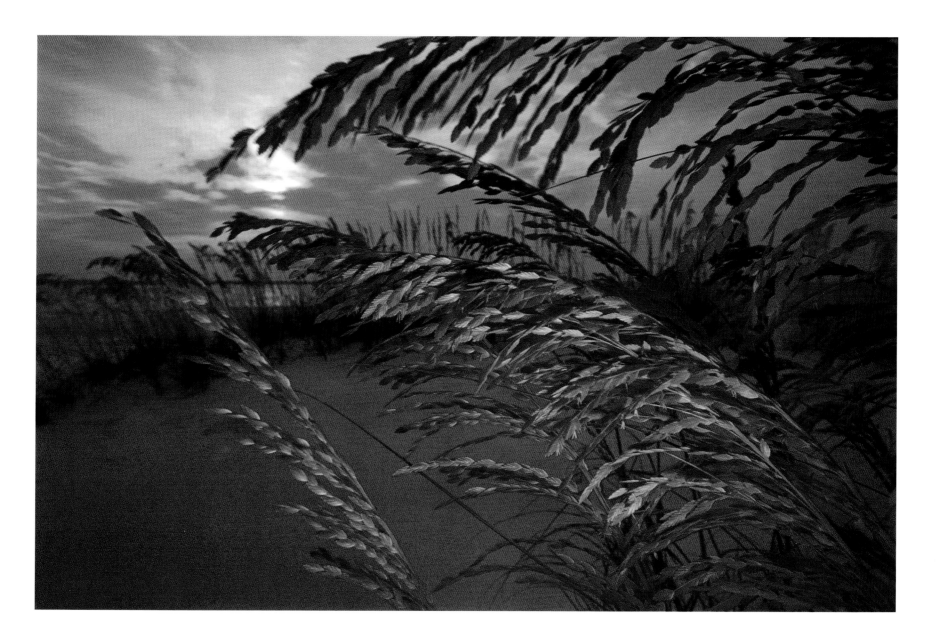

Search for a Zen View

Suwannee River and the Florida Trail, Hamilton County, 1998

Mythic river of the Old South, the Suwannee stirs the soul like few others. Dipping the blade of a canoe paddle into its black water is to touch the heart of natural Florida.

But there's another way to experience the river. On foot.

For nearly fifty miles between the Stephen Foster Folk Culture Center State Park in White Springs and Suwannee River State Park in Ellaville, the Florida Trail blazes a pathway of discovery to a world of sinkholes and springs, bluffs and ravines.

The trail frequently leads hikers deep into floodplain woods on a meandering course where the presence of the river can be felt, but not seen. Unfailingly, the trail always returns to the river and its tantalizing views through the trees.

In the challenge of photographing the Suwannee, this repeating reconvergence of trail and river stimulates the eye. In my canoe, surrounded always by water, I sometimes struggle to really *see* the river. Hiking the trail offers the artfully framed views of the river that bring focus to my vision.

The architect Christopher Alexander describes the dilemma of the Zen view in his book *A Pattern Language*. Building a small stone house high in the coastal mountains of Japan, a Buddhist monk chose not to place any windows in his home affording a view of the beautiful, distant ocean. Instead, he placed a narrow opening in the courtyard wall facing the sea. What is it that happens in this courtyard? A fleeting glimpse of the ocean awaits those who walk past the opening in the wall. No one who sees the view can forget it. Even for the man who lives there, coming past that view day after day for fifty years, its power will never fade.

This is the essence of the problem with any beautiful view. One wants to enjoy it and drink it in. But the more open it is, the more it shouts, and the sooner it will fade. Gradually the intensity of its beauty will fade.

The view from the trail along the river is an ephemeral experience, and it is time to move on. A soft rain falls as I finish making my picture. Hoisting my camera bag and tripod to my shoulder, I pause. And behold the Zen view one last time.

The photograph was made with an 18mm lens on Fujichrome Velvia slide film. A Nikon A-2 warming filter and fill flash were used to enhance the green color during the 15-second exposure.

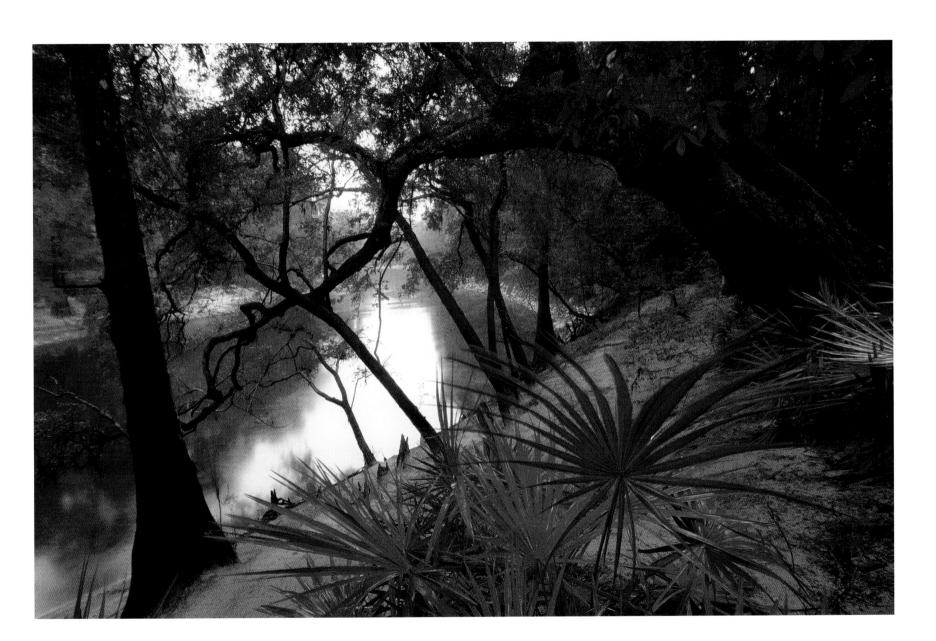

A Sculpture in My Viewfinder

Great Egret, Gainesville Duckpond, 2002

Camouflage, it appears, was not part of the master plan in the evolution of the great egret. While protective coloration enables many animals to blend into the landscape, no such advantage accrues to the great egret, whose striking white form is common throughout Florida.

Early in the twentieth century, the state was awash in great flocks of egrets and other wading birds. Demand for their distinctive plumes as decorative adornments on ladies' hats fueled the slaughter of hundreds of thousands of the birds before federal legislation, urged by groups including the National Audubon Society, banned the carnage.

Public opinion was swayed by the efforts of J. N. "Ding" Darling, whose editorial cartoons, published in newspapers nationwide, derided those who found sport in the bloodshed of birds. After winning the Pulitzer Prize three times for his editorial cartoons, Darling headed the U.S. Biological Survey, the forerunner of the U.S. Fish and Wildlife Service, and was largely responsible for the establishment of the network of game refuges in the country today. Darling's legacy was honored in the naming of one of America's premier birding meccas, the J. N. "Ding" Darling National Wildlife Refuge on Sanibel Island.

Back in Gainesville, a great egret, seemingly oblivious to my approach, eyes its next meal in the shallow waters of the historic district duckpond. Death will come quickly to some unsuspecting frog or fish, and with a life in the balance, the tension I feel in concern for my picture seems petty. I admire the fluid curves of the egret, and its delicate nuance of tone.

There's a saying in the trade that if your pictures aren't good enough, you're not close enough; and I drop to my knees to inch forward in the overcast light. No cryptic coloration here; I'm grateful this immaculate bird stands in such stark relief against the background. Like the bird I am stalking, I wait, patiently.

A winter rain begins to fall, and the pond is soon peppered with fat raindrops. I shift my focus, literally and figuratively, drawn to the mesmerizing staccato of rain dancing on water. Like a sculpture in my viewfinder, the egret stands guard in the foreground.

The photograph was made with a 70–300mm zoom lens and a Nikon D1H digital camera.

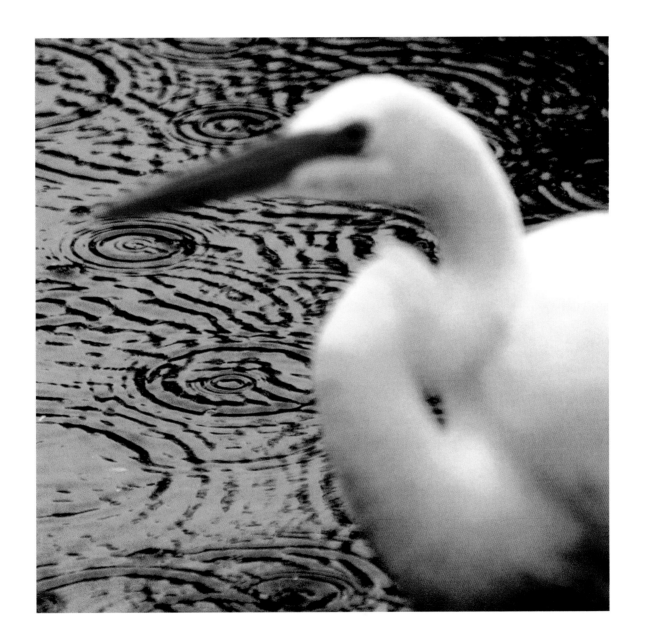

Dogwood at Sunset

Ichetucknee Springs State Park, Columbia County, 1996

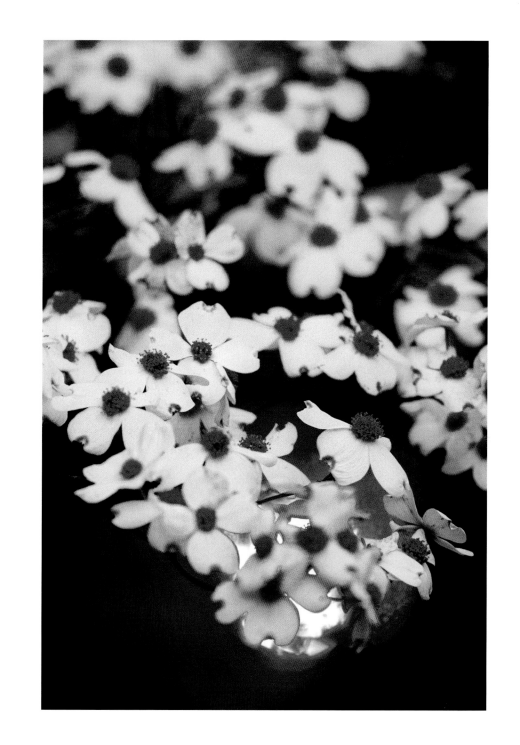

On f/8 and Being There

Fury in the Sky, Santa Fe River at Poe Springs, Alachua County, 2000

What does photography have in common with fishing, physics, and football? As with other fields of endeavor, luck favors the prepared photographer. It's a safe bet that in the realm of observing natural phenomena, you can depend on serendipity. Rainbows and lightning aren't exactly rare, but they are unpredictable. Yet this unpredictability is what makes them so special, and so predictably frustrating to the nature photographer.

Annie Dillard writes in *Pilgrim at Tinker Creek* of the spectacle of observing a bird in flight collapse and die at her feet. Try getting that on film. The first step in photographing transitory natural moments is, of course, simply being there. The second step is having a camera and knowing how to use it.

"F/8 and be there," is a cliché used in photography to describe a publishable moment whose only demand on the photographer is to point the camera and shoot. The phrase refers to a common lens aperture used in photography, and while not intended to be complimentary, it nonetheless underscores the fact that someone with a camera showed up and was instinctively open to a picture presenting itself.

How many times have we wished we had a camera when nature came knocking with the gift of a spectacular sunset, or the sight of sandhill cranes rising in foggy flight, or a striking juxtaposition of Venus and the crescent moon in the predawn chill?

Murphy's first law of sports photography says the crowd always roars loudest when you're changing your film. Murphy's lesson for nature photographers is don't leave home without your camera. But for photographers who take pictures for a living, there are times (like weekends) when we just don't want to be saddled with serious gear. That's when I break out my Ph.D. camera (push here, dummy).

My little Nikon point-and-shoot camera was the camera of choice when I attended a friend's summer wedding at Alachua County's Poe Springs Park. As the bride and groom gathered at the appointed hour for the ceremony with friends and family at the park lodge, an angry sky was brewing over the Santa Fe River bordering the park. My wife and I walked down to the dock in time to see and feel a classic Florida thunderstorm that threatened to blow us into the river.

I wished at that moment that my "real" camera was on my shoulder and not in my car two hundred yards away. But I instinctively pointed my modest snapshot camera into the maw of the big storm and snapped a panoramic sequence of three overlapping pictures that took in the fury in the sky bearing down on us. Fat raindrops and fierce lightning followed us up the hill as we ran to rejoin the party.

Stitched together in the computer, the three pictures became one, providing my friends and me with a visual keepsake of the stormy beginning to their married life.

The photograph was made on Fuji Superia 200 color print film with a Nikon Action Touch waterproof point-and-shoot camera. The camera was vertically aligned to make three overlapping pictures, replicating the angle of view of a single-lens reflex camera with a 20mm wide-angle lens. The three pictures were seamlessly blended using Photoshop imaging software.

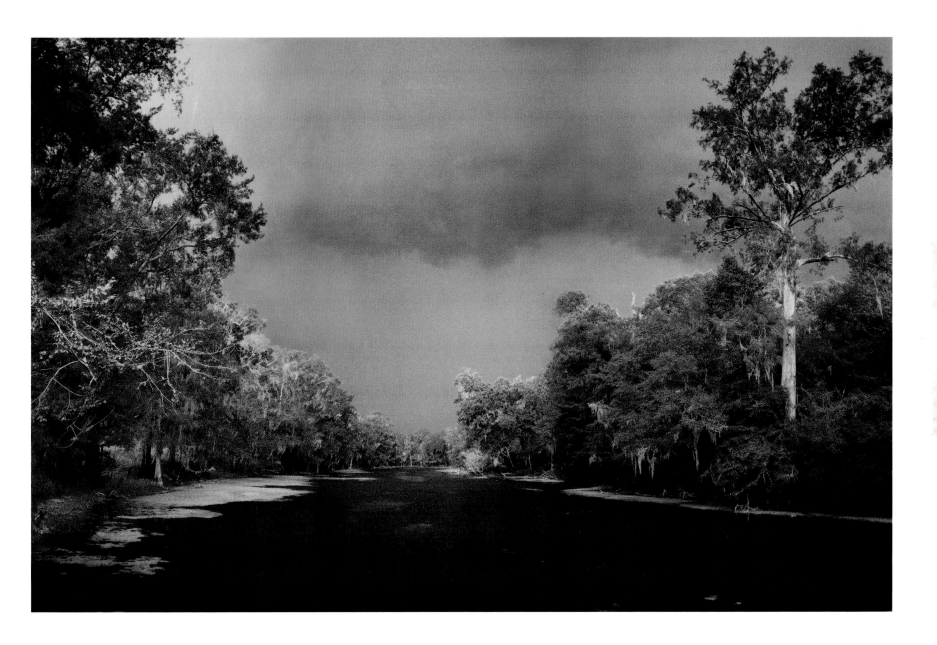

A Day Like Any Other

The Millennial Sunrise, January 1, 2000, Paynes Prairie Preserve State Park, Alachua County

Out on Paynes Prairie, the first day of the millennium was a day like any other.

Birds stirred. Reptiles languished. Nothing much happened, and yet everything was happening. Species evolved. The universe expanded. The sun rose, and the world moved on.

Arriving in unison, a raft of sixty or so white pelicans glides in from the west, joining an avian mix of cranes, storks, herons, ibises, egrets, and vultures. In the predawn chill of La Chua Trail, it's apparent that Paynes Prairie, the defining natural feature of my part of Florida, is just where I need to be to experience the millennial sunrise.

For most animals on the prairie, life will go on. For some, the new day will bring an abrupt and terminal reminder that there is no escaping the shackles of the food chain. For me, there is no eluding the long-awaited anticipation of this moment. In a place where our calendars seem meaningless, the sun rises on cue, bathing the day in sweet light. Like a creation tableau from the Book of Genesis, the scene before me feels biblical in scale; a great visual feast laid out, it seems, for my eyes only.

The photograph was made with a 400mm telephoto lens on Fujichrome Velvia slide film.

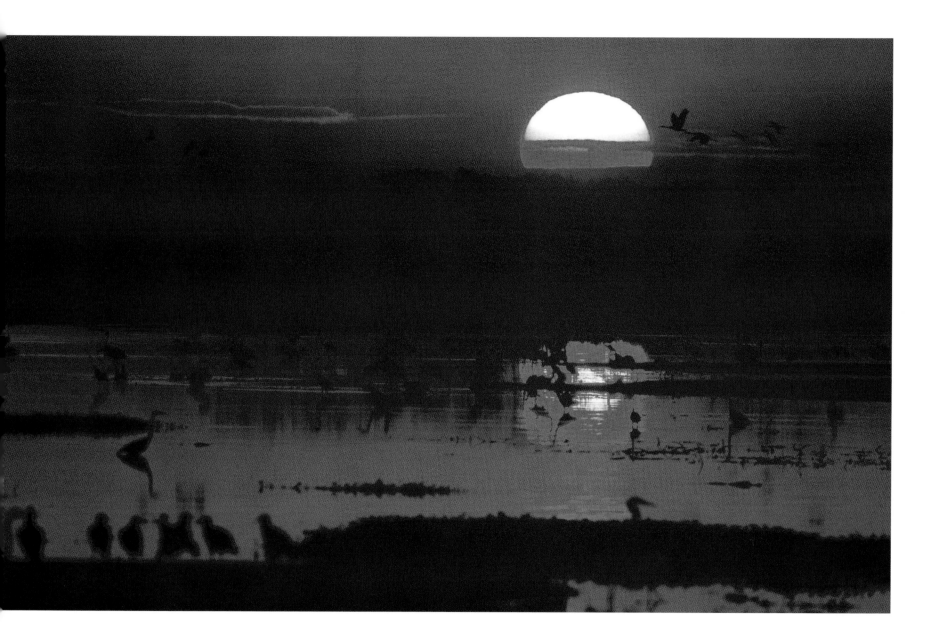

Coming Home

Gopher Tortoise, Morningside Nature Center, Gainesville, 1989

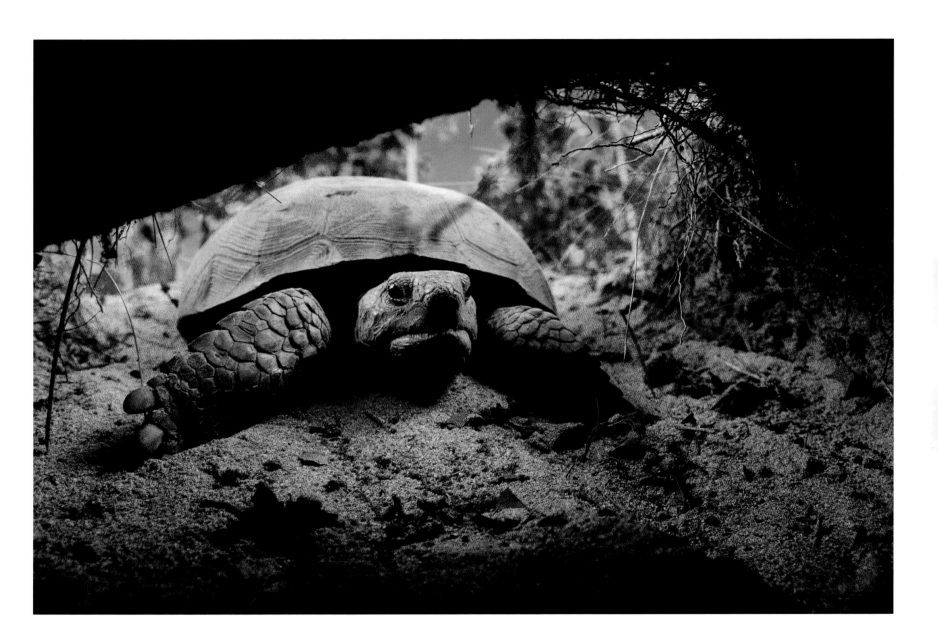

The End of an Era

Fish Shack on the Chassahowitzka River, Citrus County, 1997

Fast-growing Citrus County proudly stakes claim to seven rivers. On the list are three that are birthed by first-magnitude springs whose sizable runs to the Gulf of Mexico can only be called a river. They're all impressive, but Crystal River and Homosassa River feel more like thoroughfares for a boat parade than places of peaceful refuge. Somewhat off the beaten path is the Chassahowitzka River, a real gem favored by those who canoe and kayak.

The shallow waters of the Chassahowitzka self-limits the size and frequency of boat traffic. The river ends its six-mile sojourn to the sea at the Chassahowitzka National Wildlife Refuge. Paddling through this subtropical paradise on a quiet day, it's easy to imagine the celebrated artist Winslow Homer—over there, beneath that cluster of palms—creating the dramatic paintings that colored America's perception of Florida a hundred years ago.

Old fish shacks occasion the riverbank. So long a part of the landscape, they've become part of the fabric of the river. Their simple lines take us back to the age of Florida's vernacular architecture, when architecture-without-architects yielded buildings whose materials, scale, and placement seemed more in touch with nature.

Standing atop my sixteen-foot ladder tripod in the shallow river at sunrise, I composed this picture with a sense that a piece of Florida history lay before me.

That was the thinking that prompted me to make this picture, part of a collection of photos I created on assignment for the Florida Humanities Council for use in a special issue of their magazine devoted to the culture, nature, and history of Citrus County. The editors chose this picture for the cover.

I later learned that the old fish shack had been destroyed. The decaying relic, and several others on property owned by the Southwest Florida Water Management District, was deemed a safety and navigational hazard and the Citrus County airboat fire brigade was called in to destroy them in a training fire.

Whether it's news photography or nature photography, what sustains photo professionals is a sense that, over time, our efforts hold up a mirror to our community, creating a tangible record of its changing face. We record history, one picture at a time.

The photograph was made with a 24mm lens and a 2-stop graduated neutral density filter on Fujichrome Velvia slide film.

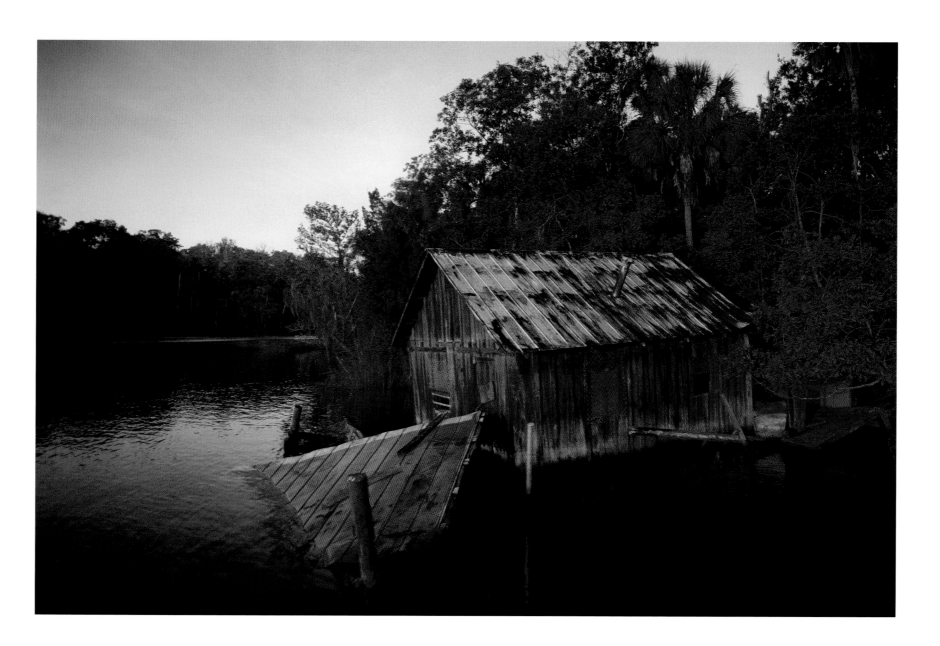

A Truce Declared

Dance of the Sandhill Cranes, Marion County, 1998

Cattle rancher Kay Richardson declared a truce years ago in his feud with the sandhill cranes. Now, it seems, the cranes have only themselves to battle.

The great birds are highly social and usually get along well in close contact with each other. But if they're defending an individual feeding spot or nesting territory, tempers can flare and feathers may fly.

Called "bill sparring" by wildlife experts, the brief attack depicted in the photograph passed in an instant, and the birds resumed the task of scratching and pecking through cow manure in search of a meal. Such aggressive displays are not uncommon on the family ranch that Richardson manages on a sweep of land that hugs the palm-studded shoreline of Orange Lake in Evinston, at the Marion-Alachua County line.

Richardson is a soft-spoken man with a clear sense of stewardship for the lakefront land that is among the area's most beautiful. Tending to the details of running a commercial cattle operation, he'll occasionally pause to observe bald eagles, deer, wild turkeys, foxes, and the sandhill cranes that some years number more than a thousand.

The Richardson family history on the sprawling Evinston ranch dates back more than a hundred years. But Richardson notes that the cranes only began to frequent his family's property after cattle ranching ceased on nearby Paynes Prairie in the 1970s, when the state acquired the prairie as a state preserve.

Soon thereafter, the great flocks of cranes that summer in Wisconsin and Michigan began to fly into Evinston every fall. The cranes are attracted by the abundance of food here, and by the open pastures that afford them a sense of security. Roosting at night on Orange Lake, Lake Tuscawilla, and Paynes Prairie, the cranes arrive at Richardson's around sunrise to feed on spilled corn and, rather inelegantly, the passed corn that is undigested in cow manure.

But the birds can be a pest, Richardson says, and he's paying a price for their presence on his land. The cranes are fond of grubbing the freshly disked soil in which he plants winter forage such as rye grass. In their search for worms and insects, the birds uproot germinating grass seed, causing the plants to die.

Years ago, in exasperation, Richardson gave chase on an all-terrain vehicle, racing after his unwelcome visitors to scare them away. It was a futile exercise, he says. So too was his next step—rigging up a propane gas gun set to discharge with a deafening explosion every thirty seconds. The cranes were undeterred.

Richardson came to realize the cranes were here to stay. Creatures of habit, the same birds return to his pasture year after year in a thousand-mile celebration of one of nature's great mysteries—long-distance migration. His heart softened a bit for the birds with the sonorous trumpeting that thrilled naturalist William Bartram, who noted their presence hereabouts two hundred years ago in his *Travels*. On several occasions, Richardson has even freed cranes that were caught in his barbed wire fences.

Richardson sees himself as a businessman whose operation also benefits the environment. "A lot of birds and other wildlife benefit from the presence of the cattle and our keeping the weeds down," he says. "If this wasn't a commercial cattle operation, we wouldn't have the birds here."

The photograph was made while lying inside a homemade PVC pipe-and-burlap blind, with a 300mm lens on Fujichrome Sensia slide film.

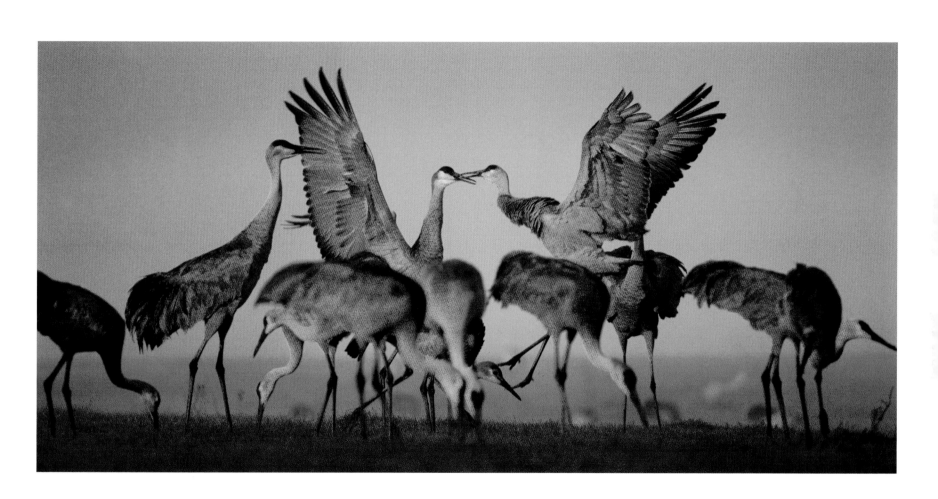

Veins of Fire

Night Lightining with Jupiter, Newnan's Lake, Alachua County, 1987

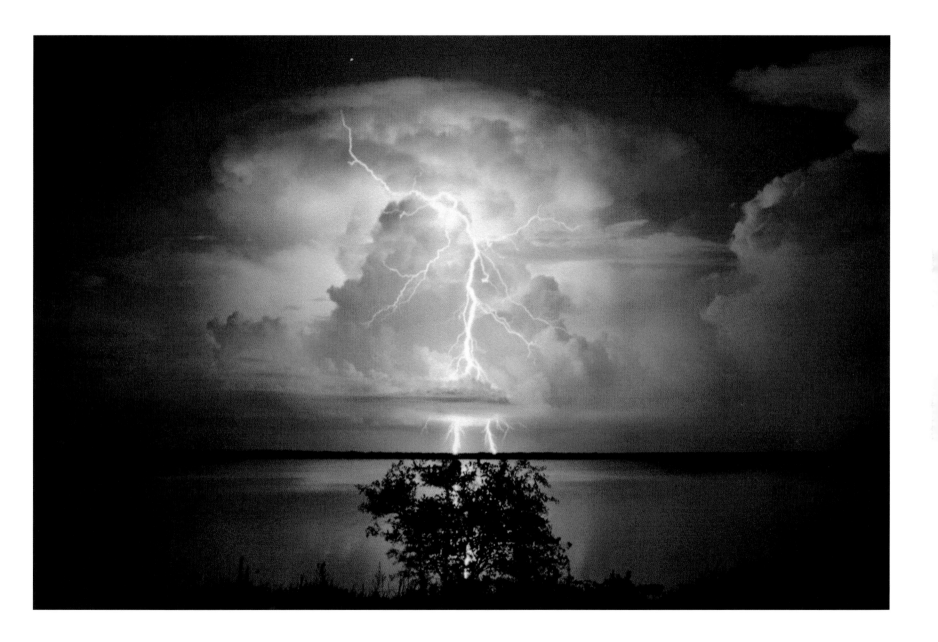

The Key to Solitude

Silver River State Park, Marion County, 2000

I'm looking for a new bumper sticker. Mondays: What a Beautiful Way to Spend One Seventh of Your Life. It would be confusing to other motorists, but in these words lies a truism about the pursuit of solitude in natural Florida: weekends can be awful, and they're getting worse every year.

The 2000 census released numbers of note to Floridians who value solitude in their time outdoors. Three million more people call Florida home than in 1990, a twenty-three percent increase in just ten years.

That's sixteen million of us and counting, plus visitors, crowding the Sunshine State, and we've got nearly a million registered boats with which to traverse our waterways. That's a lot of company on the water, invited or not. News reports a couple of years ago pegged the July 4th holiday boat count at more than six hundred at Silver Glen Springs on Lake George in the Ocala National Forest. When I go to the river, I prefer a vista of water and trees, not fiberglass and aluminum.

The last time I went to the Silver River on a summer weekend, the slow-moving boat parade felt like the thick crawl of Saturday night traffic inching up Ocean Drive on South Beach. Dodging boat wakes and gas fumes, families in canoes competed for space with ocean-worthy boats nearly as long as the river is wide.

So I came up with a theory about how to have the Silver River all to myself. It's simple, really. Just go before sunrise on a Monday in January when it's twenty-eight degrees. I tested my hypothesis; it worked flawlessly.

There are times when a party on the water is great fun, and there are times when the call of the river insists that we go alone. In solitude, we are open to the revelation of nature's artistry. Alone, I look, and I am able to see.

The photograph was made with an 18mm lens on Fujichrome Velvia slide film.

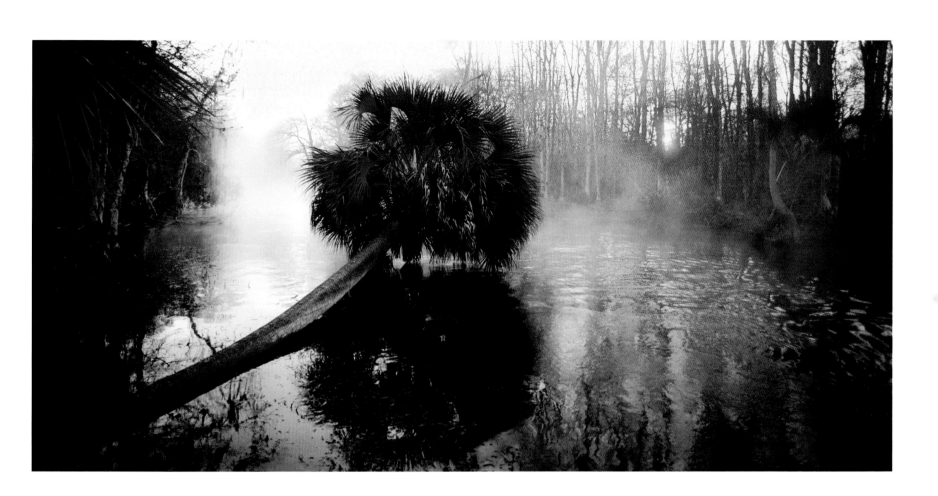

Food for Thought

Juniper Creek, Ocala National Forest, Marion County, 2000

Stalking in the shallows of Juniper Creek, a great blue heron suddenly strikes, skewers and is gone in the morning light, its hapless prey stunned and dying, on its way to becoming a meal.

As I paddle downstream, I replay the sight in my mind, grateful for the privilege of witnessing at close range such a primal act of survival. I'm grateful too that such a fate is unlikely to befall me, the alligators in the creek notwithstanding. It's a curious affair, this act of eating, in which the survival of living things, from microbes to mammals, is predicated on destroying and eating one another.

My grumbling stomach calls me back to Juniper Creek. Soon I'll turn to paddle back upstream, where my own breakfast, safely packaged and refrigerated, awaits my return to the cabin. On this morning, mine is the luxury of feeding my soul with snippets of celluloid—camera in hand, depicting a struggle from which I am blissfully freed. I wonder about the course of events that enable my life of abundance and comfort, with scarcely a thought or concern for my next meal.

But what is the real price we pay for the convenience of fast and plentiful food? Apathy, neglect, isolation? Or is it something deeper, the loss of relationship, of wholeness, of soul?

Writer Stephen Hyde ponders that question and concludes that our loss of identity with our food represents a deeper crisis in our relationship with nature.

"For many thousands of years," Hyde writes, "human survival has been a matter of walking the razor's edge between too little and too much.

"Gratitude, in primal ecologies, was the ritual acknowledgment of the need for balance, of relationship and reciprocity in a flesh-and-blood economy.

"When was the last time, if ever, you saw anyone at McDonald's offer an expression of thanks (a prayer, a song, a dance) for his or her food? Billions of burgers sold worldwide, millions of creatures and plants consumed—yet not a solitary act of gratitude, individual or corporate, no festival to honor the bovine being in myth and art and imagination, or to celebrate the annual resurrection of the potato. How can this be? What kind of heinous disrespect for the life that sustains human life does this suggest?

"Once, the rituals of gratitude informed nearly every aspect of human life. Most of these we have abandoned or forgotten. Now, try to imagine this: for every one of those burgers sold, a song raised, a life recalled, a measure of grace restored."

Food for thought, as we consider our blessings at our next meal . . .

The photograph was made with a 300mm lens on Fujichrome Velvia slide film. Using a shutter speed of 1/60 second, I panned the camera with the moving heron to photograph a motor-driven sequence of the bird lifting off.

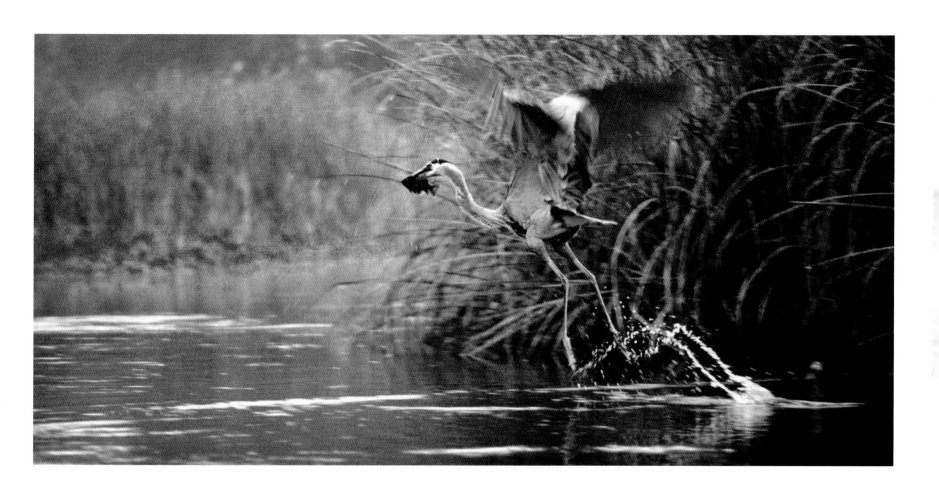

The Last Outpost

Fort Jefferson, Dry Tortugas National Park, Monroe County, 1998

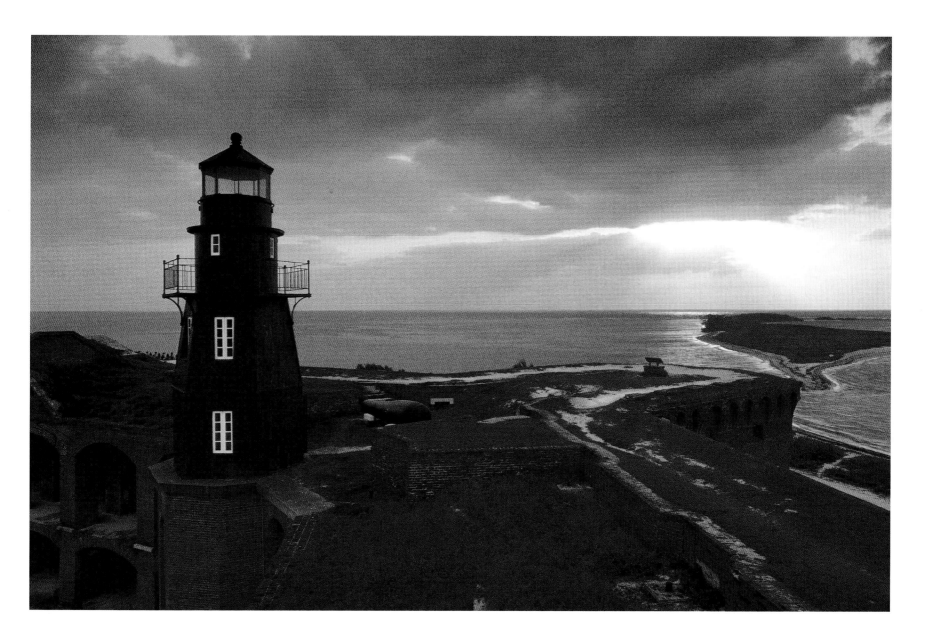

Less Is More, Naturally

A Summer Day, July Springs, Santa Fe River, Columbia County, 1996

At the center of the Hippodrome State Theatre's stage production of Yasmina Reza's *Art* in the Fall of 2000 was an outrageously expensive white-on-white abstract minimalist painting that depicted essentially nothing but nonetheless helped to reveal much about contemporary culture and the nature of friendship during the course of the play.

Managers of the Gainesville playhouse expanded the onstage exploration of minimalism by inviting two dozen local artists to make their own artistic statements in the spirit of the play.

They handed each of us a blank canvas and a three-week deadline. Our efforts were to be displayed in the Hippodrome Art Gallery for the run of the play. An interesting assignment, to be sure.

I strive to make pictures that get the job done in a hurry. It's said that the average reader spends about two seconds "reading" the average published photograph, and so I've been conditioned to make my pictures compositionally simple, unambiguous in content and devoid of extraneous detail. But minimalist? Hardly. I try to load my pictures with recognizable visual cues that relate to the story at hand and play on the viewer's bank of knowledge and experience.

It didn't take me long to settle on my contribution to the show. I chose from my files a photo of a sweet little spring on the Santa Fe River in North Central Florida, a quiet picture ill-suited to the task of illustrating news stories about falling aquifer levels or rising nitrate levels in the springs. Like many of my unpublished nature photos, this simple study in black and white and blue was shot just for me.

Lying on my back in ten feet of water, cradling a miniature scuba tank on my chest, I'm just daydreaming; watching the undulating eel-grass swaying in the current of July Springs as my air bubbles reach for the sky. A puffy-white popcorn cloud drifts by, brilliantly backlit by the summer sun. I reach for my Nikonos to make a picture, and the cloud moves on.

Even under water, the camera points both ways, and with its uncertain perspective providing the casual viewer with minimal information, I suspect this picture says less about the subject than it says about the photographer. It's one of those pictures you have to study to figure out. But then, not all pictures are meant to be consumed in two seconds.

The photograph was made with a Nikonos underwater camera and a 15mm wide-angle lens on Fujichrome Velvia slide film. An artist friend, Anthony Ackrill, supplied the brush-stroke edges, which I blended into the picture in Photoshop. For the gallery show, the finished photo was digitally printed on canvas and stretched onto a wooden frame, lending to the painterly effect.

The Color of Paradise

Paynes Prairie Preserve State Park, Alachua County, 1998

Paynes Prairie, Florida's first state preserve, is a designated national natural landmark. And yet this vast gem on Gainesville's southern fringe remains largely unknown, both to casual travelers and to those who live here.

In the spring of 1998, rising water levels on the prairie very nearly shut down U.S. Highway 441, which crosses the prairie; generating sizable local headlines and lots of sightseers out for a Sunday cruise. But there are limits to our ability to experience and appreciate nature from inside a car, even if we slow down to enjoy the view of the alligators as they bask on the edge of the asphalt. There's another side of the prairie that speaks to me. Far from the din of the highway, a stunning cluster of sinkholes stretches into the woods along the prairie's north rim.

The sensitive and pristine sinkholes, numbering nearly a hundred, are representative of the porous and dynamic karst geology of much of Florida. Following fractures in the bedrock, the sinkholes lie in a perfectly straight line, not easily discerned through the dense vegetation. Here, only a footpath disturbs nature's perfection.

The Rim Ramble Trail leads a group of Saturday morning hikers through this lush and lovely landscape, saturated with the color of paradise. I lag behind as the rest of my group pushes on to Persimmon Point, a dramatic bluff overlooking the prairie, where we will camp for the night. Transfixed by the scene pictured here, I pause to raise my camera in a soft rain. This could be Florida's Eden, it seems to me.

I'm not alone in my thinking, it appears. William Bartram, the loquacious eighteenth-century naturalist who explored Florida, extolled the beauty of these very sinkholes in his classic, *Travels*. David Webb, distinguished research curator at the Florida Museum of Natural History, accompanied Archie Carr here on one of Carr's famed ecological field trips in the early 1970s. As Webb tells the story, Carr related how the English poet Samuel Taylor Coleridge directly credits Bartram's description of these sinkholes as the inspiration for the opening line of his poem, "Kubla Khan."

> In Xanadu did Kubla Khan
> A stately pleasure-dome decree:
> Where Alph, the sacred river, ran
> Through caverns measureless to man
> Down to a sunless sea.

"It's a wonderful link to romantic poetry and English literature and the grandeur of our prairie," Webb says.

Throughout history, sinkholes have cast a potent spell. The Underworld, it was believed by some, lurked just beneath. Consider the name given to the state's best-known sinkhole, Devil's Millhopper, on the north side of Gainesville.

But for photographers, sinkholes command humility. Take a picture of a mountain, and what you get looks like a mountain. But pictures of sinkholes look flat.

My vision has failed me many times in my quest for a picture of a sinkhole that actually looks like a sinkhole. El Niño bailed me out this time. As the rest of the prairie was awash in water, so too were the sinkholes in the woods. Light rain frosted the surface of the water, lending welcome depth to the scene, and silvery translucence.

The photograph was made with a 24mm lens, a Nikon A-2 warming filter, and a polarizing filter on Fujichrome Velvia film.

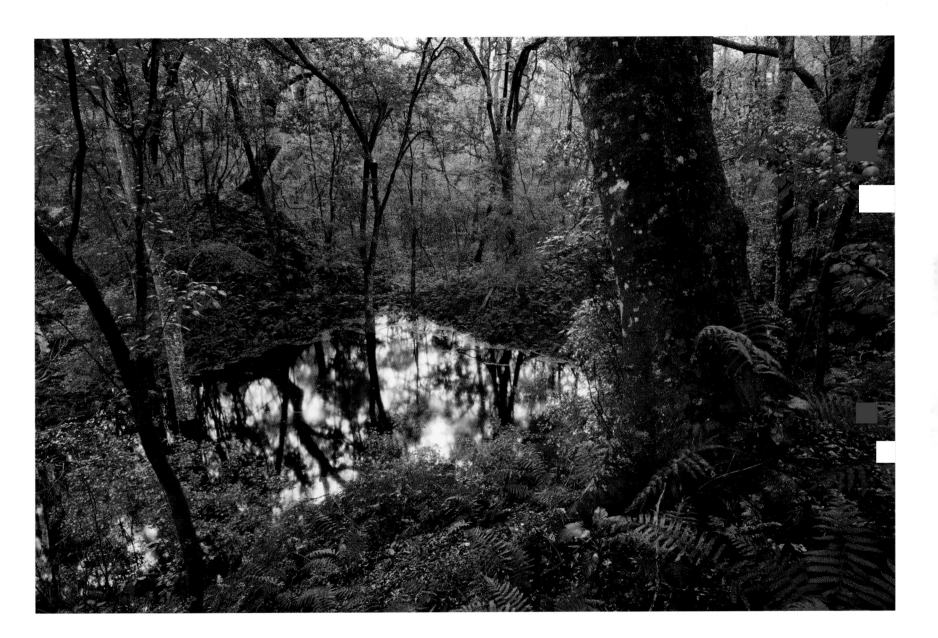

Flight of the Cranes

Sandhill Cranes, Paynes Prairie Preserve State Park, Alachua County, 1981

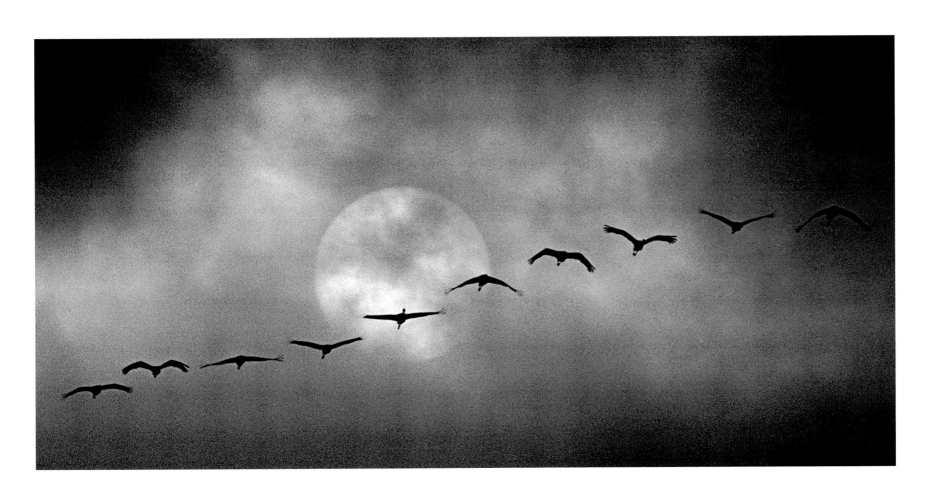

Water World

Flooding on Newnan's Lake, Alachua County, 1998

In the beginning, there was water.

Most of what one day would come to be known as Florida lay beneath a warm shallow sea. Thirty million years ago, an archipelago of small islands stretched south from the mainland, defined most notably by the Lake Wales Ridge. Water was the dominant feature of a place marking geologic time before the land rose slowly to become the peninsula we call home.

Then, as now, Florida was being carved and shaped and eroded by water. Abundant rains on the landform that arose from the sea gave birth to a remarkable array of lakes and rivers and springs, bringing a freshwater elixir of life to sustain a diverse biota. Water levels rose and fell through the ages, a dynamic force that reinvented the landscape through flood and through drought.

Long before floodplain maps and flood insurance, change was the only constant in the hydrology of Florida. Even if Florida weren't today populated by transplants, we'd still lack the collective memory of a time when sharks, not alligators, were the dominant predators fifty miles inland from the coasts we know today. But the land remembers. Fossilized sea life riddles the state and in many of Florida's creek beds, a fresh batch of shark's teeth flows from the earth with each heavy rain.

Surrounded by seawater, the Florida peninsula in 1998 found itself drenched in freshwater. After a thirty-year rainfall deficit, thousands of people who ordinarily enjoy going to their favorite rivers and lakes now found those rivers and lakes coming to them. For many, the flood was a time of stress, hardship, and loss. But there was a certain beauty to the way in which water once again transformed the landscape, suggestive of a time when Florida emerged from the sea.

Docks on Newnan's Lake in Gainesville slipped under water for several days, and it looked like Lakeshore Drive on the lake's west side would soon be submerged as well. Like lakes throughout the region, Newnan's rose dramatically following thirty inches of rain in a little more than three months. That's a lot of water. Not counting the runoff draining into the lake, a single inch of rain pours more than two hundred million gallons of water directly onto the 7,400-acre lake, more than the entire flow of the Ichetucknee River in twenty-four hours.

The high water created an opportunity for a picture I've thought about since I moved to the lake in the 1970s, confident the water would some day rise to the level of the docks, less certain I'd be around to see it when it finally happened.

As I paused one day by the dock to consider the picture possibilities, a friend happened by on his bike. His serendipitous arrival inspired a two-wheeled variation to the walking-on-water picture I had envisioned, and we arranged to meet at the dock the next morning with a fellow cyclist for a shot at making a memorable picture of the flood of '98.

The photograph was made with a 24mm lens on Fuji Super HG 400 print film. My diving wetsuit provided flotation and warmth, a welcome comfort in the chilly water.

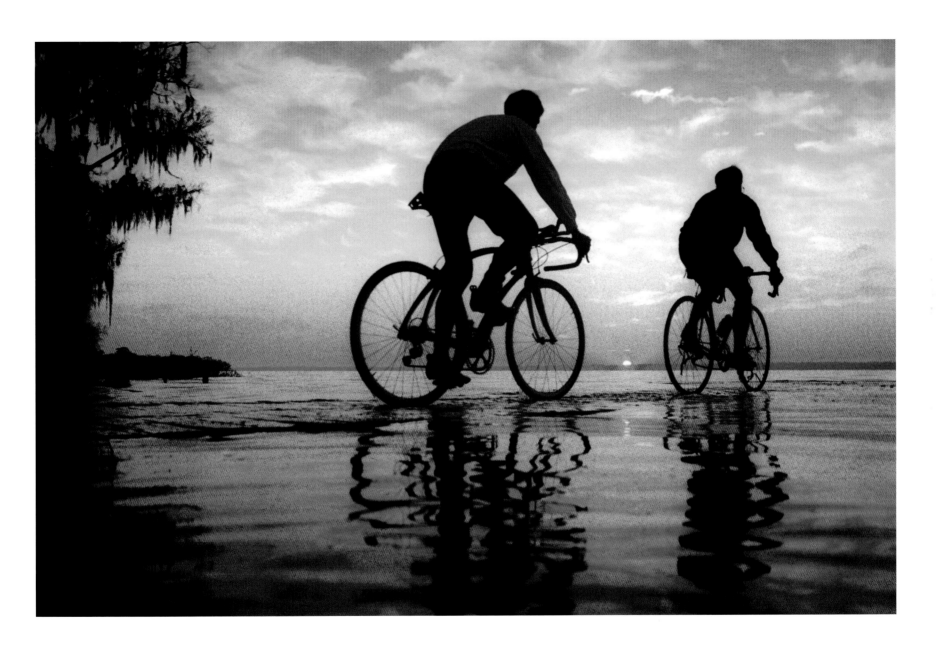

Return to Big Shoals

Big Shoals State Park, Suwannee River, Hamilton County, 2003

I remember well the first time I went to Big Shoals on the Suwannee River. In the summer of 1984, I headed north from Gainesville with my canoe and my cameras, ready to begin a life project to tell the story of Florida's most famous river in pictures.

When I planned my first trip to the Shoals, I had no maps to pinpoint its location or signs to guide the way. Enshrouded in mystery, the remote Big Shoals had grown in my mind to symbolize all that is wild and untouched in Old Florida.

Putting in a mile upstream from the Shoals, I paddled for thirty minutes before I heard a whisper in the wind grow to a thundering roar, and I rounded a bend to see whitewater churning through a tangle of exposed limestone. A day alone here at the state's biggest rapids and three more days of solitude downriver changed forever the way I view natural Florida.

I went back to Big Shoals early in 2001, the first time I'd been there since construction began in late 1999 on an ambitious list of improvements designed to make this scenic stretch of the Suwannee more publicly accessible.

As the saying goes, the times they are a changin'. In sleepy White Springs, which a century ago attracted trainloads of tourists to take the healing waters of its famous sulphur spring, I drove past the new Florida Nature and Heritage Tourism Center on the banks of the Suwannee. Signs now point the way to Big Shoals five miles upriver.

A paved road in the woods greeted me where once an unmarked lane led to the river. A bathroom building, designated parking areas, an informational kiosk, picnic tables, trash cans, signs and fences stood ready to manage and accommodate an expected surge in visitors.

Plans are in the works to pave a 3.5 mile hiking and cycling trail on the 3,800-acre state-owned property. Future plans call for construction of an overlook at the Shoals and lots of tourists to take in the view. Big Shoals, state land managers say, is perfect for the ecotourism that environmentalists often say they want.

Some in the environmental community disagree. Canoe guide Stephen Williams, who put me on the river on my first Shoals trip in 1984, questions the wisdom of "using what remains of Florida's natural heritage as profit centers."

"Is Big Shoals to be just another destination for the fun-loving visitor to have a good time?" he asks. Williams points to a Nature Conservancy study that in 1978 identified Big Shoals as one of the Suwannee's two most ecologically diverse and intact regions. He suggests if ever there was a place in North Florida worth serious protection, it is Big Shoals.

"Want to take a walk? Try almost any beach in Florida or any once-quiet place you might remember which has been improved with access for parking for cars and buses. We don't need another road or parking lot anywhere near the places we care about," Williams says. "We need to find the courage to allow some places to exist on their own terms."

The photograph was made from the JohnnyPod 16-foot ladder tripod with a 17mm lens on Fujichrome Velvia slide film. A ¼-second shutter speed blurs the rushing water as the river crosses an erosional scarp into the Gulf Coastal Lowlands, dropping about seven feet over two hundred yards. When the Suwannee is running sixty feet above mean sea level, Big Shoals is a Class III rapids.

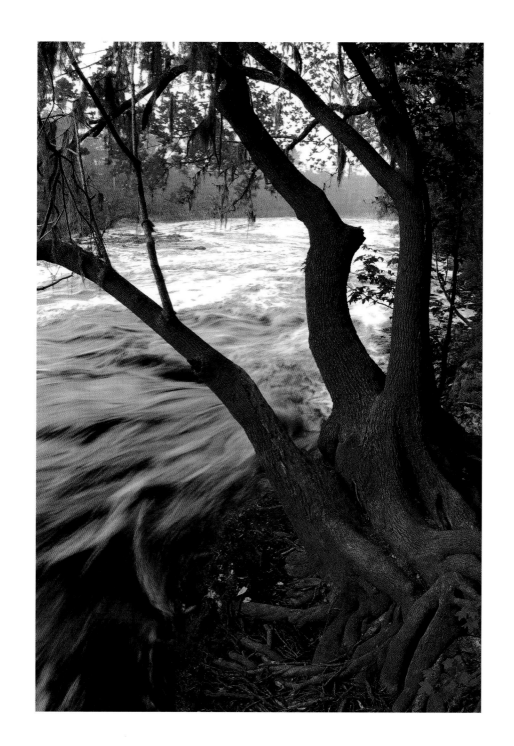

Day Begins Anew

Orange Lake, Alachua and Marion Counties, 1995

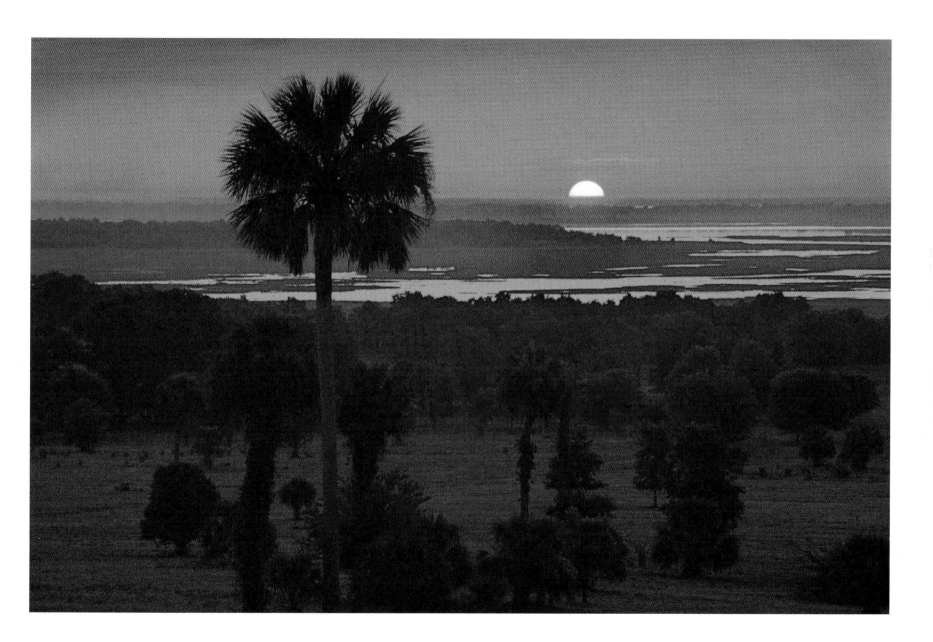

At Work in a Celestial Playground

Lunar Eclipse over the Century Tower, University of Florida, Gainesville, 1993

Another eclipse, another opportunity to play in the dark. In the age before digital photography, when making pictures—on film—was truly enshrouded in mystery, there were few more technically challenging assignments than making multiple-exposure pictures of ephemeral natural phenomena at night. You get one chance to get the picture right, and there's no digital reassurance that you haven't screwed it up.

I've photographed several lunar eclipses using the technique shown here. I once photographed an eclipse in the sky above a University of Florida baseball game, from the perspective of the fans in the stands behind first base. And then there was the time I was bobbing in the dark on the surface of Lake Santa Fe, wearing a flotation vest, lining up a picture of a couple standing on the deck of their sailboat, against which I would photographically superimpose the progression of the eclipse later that night.

The pictures begin in my mind's eye and are completed with the processing of the film. In this case, the University of Florida Century Tower provided the setting.

The day before the eclipse, I made a black-and-white picture of the tower using an 18mm wide-angle lens, envisioning the path of the moon arcing through the night sky above the gothic-spired University Auditorium. I marked my spot on the pavement with fluorescent orange spray paint and returned to the darkroom.

I made an 8 x 10" black-and-white print of the picture and used a drafting ellipse template to scribe a gentle curve through the sky, indicating the path I wanted the moon to follow. Using a circle template, I drew a series of circles along the prescribed lunar arc at equidistant intervals. The final work print showed the placement of all the elements needed for the picture to succeed.

I then copy-photographed the black-and-white print on color slide film, as shown in the detail photograph printed here. After processing the film, I cut away the sprocket holes from the color slide, leaving only the image of the black-and-white work print that would serve as my guide. I removed the lens from my Nikon FE2 and fastened the piece of transparent film to the camera viewfinder screen with a thin strip of Scotch tape. Replacing the lens and looking through the viewfinder, I could see the image of the leaning brick tower and a string of black circles superimposed against my desk in the background. I was ready for darkness to fall.

I returned to campus at dusk, found my spot of orange spray paint, and set up my camera on a tripod. Looking through the viewfinder, I carefully adjusted the aim of the camera to make the image of the tower depicted on the viewfinder film template precisely align with the actual tower. Just before dark, with the sky a deep purple-blue, I made a single exposure of the tower on Fujicolor 400 print film, then went home.

Six hours after photographing the tower, and far from the bright lights of UF, I stepped into my front yard, ready for the moon to work its magic. I switched to a 300mm lens and positioned the camera on a tripod. Cocking the shutter without advancing the film, I made a series of five pictures at thirty-seven-minute intervals, progressively centering the image of the eclipsing moon in the five template circles visible in my viewfinder.

The exposure intervals were predetermined to suggest in a single still photograph a celestial event that took more than two hours to play out, with the moon exposure in the middle, shot at the midpoint of total eclipse.

Six exposures, one picture. They don't always work out, but I love making photographs like this. The tapestry of history is rich with the mythology of the night sky. It's the least I can do to allow it to inspire an occasional shot in the dark.

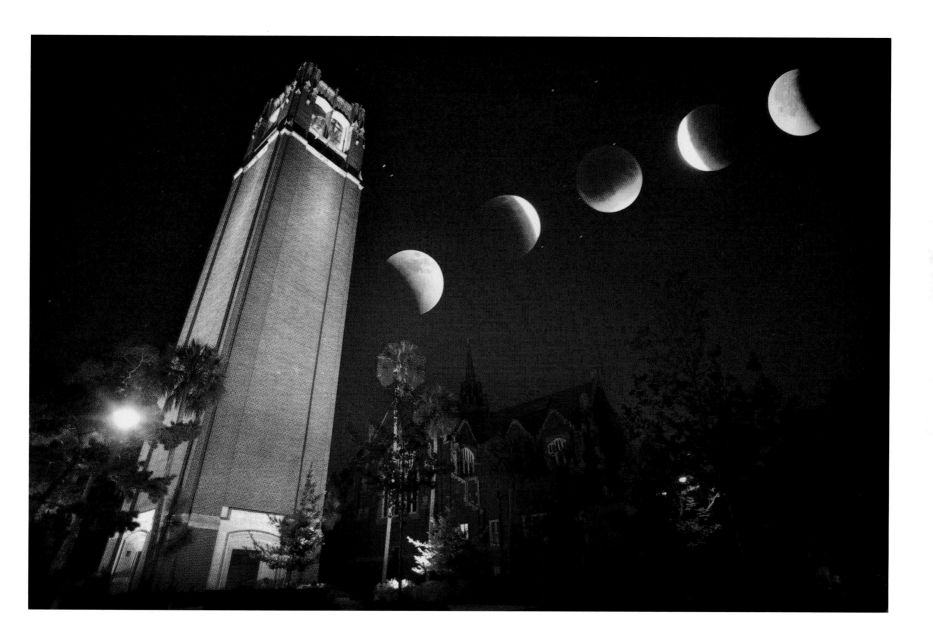

A White Christmas in Florida

Falling Creek Falls, Suwannee River, Hamilton County, 1989

The cold strayed so far south that Christmas it even snowed in the Bahamas, and many Floridians still recall years later how the arctic weather made for a memorable holiday. On the evening of December 23rd, with an appreciable coating of snow already on the ground and more to follow, I went through my mental Rolodex of locations to figure out where to go for a sunrise snow photo the following morning.

I settled on Falling Creek Falls, Florida's largest, with a drop of eight to ten feet in the tributary creek of the Suwannee, just north of Lake City. I went to bed with a plan.

It was nine degrees when I rose early on Christmas Eve and snow and ice coated all I could see. Driving north on Interstate 75, I simply lost count of the number of cars spun out and abandoned in the median.

I got to the falls well before sunrise, and by dawn's light I could see just how different the place looked from my previous visits. It sounded different, too, with an odd hush to the muffled scene. The picture lined up easily, and I soon had my first serious snow picture from Florida.

The snow quit falling on Christmas Eve but the temperature stayed below freezing, and, on the morning of the 25th, Floridians awoke to a white Christmas. Ten years later, Christmas Day of 1999 passed with comparatively balmy weather, and I realized that my picture from 1989 depicted the only white Christmas in Florida in the twentieth century.

The photograph was made with a 35mm lens on Fujichrome RFP 50 slide film.

Moonrise Ospreys

Orange Lake, Marion County, 1997

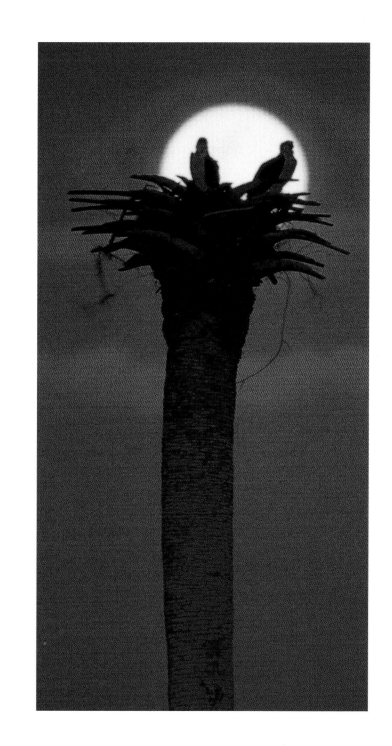

A Measure of Florida History

We should all be so fortunate to live and die with the grace and dignity of Florida's majestic live oaks. The live oak pictured here is a personal favorite. You may recognize it as the same tree depicted in the photograph of Comet Hale-Bopp earlier in this book.

What is it about these trees that inspires us so? Our calendars and our tape measures become instruments of humility when we measure our lives against theirs. To touch an ancient tree—or better yet—to hug an ancient tree, is to embrace the past.

Consider the scope of Florida history during the lifespan of this single tree in Levy County, speaking volumes in its silence. For the sake of illustration, let's surmise that this mighty oak lived, say, for a modest 130 years, then stood in death for another quarter century . . .

As the acorn sprouted in 1845, sparsely settled Florida became the twenty-seventh state with a population that wouldn't have filled the present-day professional football stadiums in Miami, Tampa, or Jacksonville. In 1864, the Battle of Olustee became the lone major battle fought on Florida soil during the Civil War. In 1880, President Ulysses S. Grant made an excursion up the Ocklawaha River aboard the steamboat Osceola.

The catastrophic freeze of 1895 wiped out much of the young state's citrus industry. By the time Gainesville was chosen over Lake City as the site of the University of Florida in 1905, the sixty-year-old oak was casting a sizable shadow upon the land.

In 1912, Henry Flagler's overseas rail line, hailed as the "Eighth Wonder of the World," linked Key West with the mainland. The racial massacre at Rosewood stained Florida's history in 1923.

Cross Creek writer Marjorie Rawlings painted a bittersweet picture of backwoods Florida with the publication of *The Yearling* in 1938. In 1945, this broad and muscular tree became a century oak just as army basic training facility Camp Blanding, for a time Florida's fourth largest city, was scaling back with the end of World War II. The Sunshine Skyway opened in 1954, trimming forty miles off the driving distance from St. Petersburg to Bradenton.

With the launch of Friendship 7 from Cape Canaveral in 1962, John Glenn became the first person to orbit the earth. The opening of Disney World in 1971 changed forever drive times in Central Florida. The old tree had been standing in death for more than a decade when a flood of Cuban refugees crossed the Straits of Florida in the 1980 Mariel Boat Lift.

Hurricane Andrew blew its way into the history books in 1992. Finally, the eyes of the world focused on Florida during the 2000 presidential election debacle, the year, I'm told, the ancient oak finally collapsed.

One tree. One state. Many stories.

The photograph was made with an 18mm lens on Fujichrome Velvia slide film.

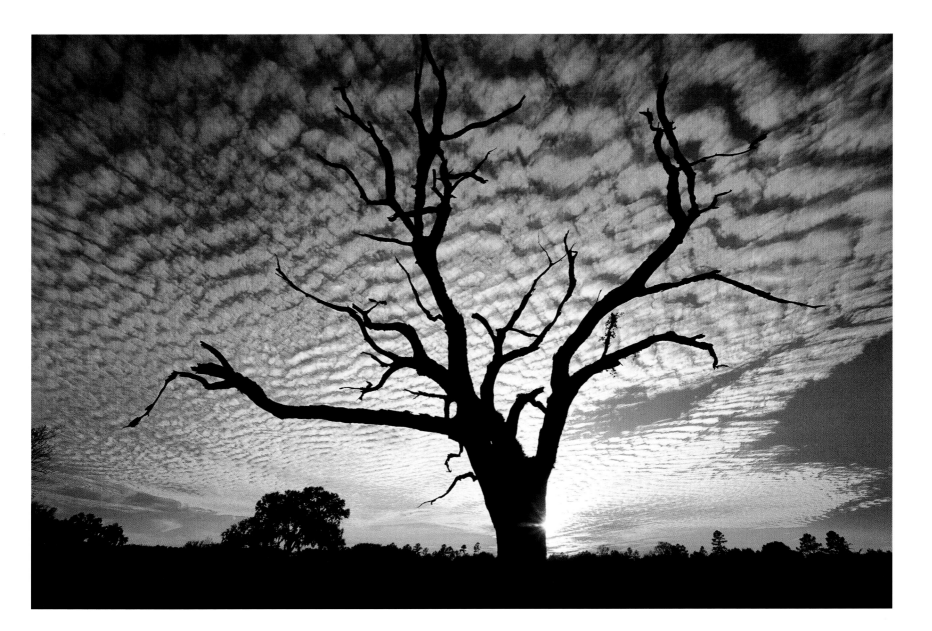

Discovering Secret Florida

Paradise Found, Ocala National Forest, Marion County, 2003

It's completely natural to see a picture of a beautiful place and want to go there in our mind's eye, now. We want information. We want to know its name and location, to feel the satisfaction of recognizing in the picture a place we already know or the intrigue of discovering vicariously someplace new.

Such pictures are a staple of magazine and newspaper articles with headlines like "Unspoiled Paradise," "Hidden Treasure," and "Secret Vacation Hot Spots." Filled with enticing detail, these articles stimulate our curiosity and demystify the world beyond our direct experience.

Ours is a culture hungry for information, and publishing is an industry whose job it is to oblige. Pictures make the world smaller, even if we never actually go to the places depicted.

We are, of course, a people thirsting for new experiences, and I suspect my picture of this lovely spring will pique a desire to find this spot and take the plunge.

Some readers will recognize this spring, though most will not. It's a little-known slice of natural Florida, not open to the general public, where I've spent many weeks with family and friends, sharing the spring with turtles and otters gliding through jade-hued waters. Lying at the end of a gated half-mile long dirt road, the property features an old cabin from which a series of steps cascades down to the spring.

A deck, perfect for sunning, cantilevers over the water. There's no other place like it in Florida. If only for a while, it has fulfilled my Florida fantasy of living with a spring in my backyard.

Nice place, you say; now where is it? For reasons I hope you'll understand, I'd rather not say. I call this picture "Paradise Found," and I'd like to keep the details of its location secret.

With most pictures I make, I'm happy to tell all. Paradise Found is in the Ocala National Forest, but I hesitate to say more. My intention here is not to tease, but rather to inspire. Off the beaten path, Florida is full of little gems that await us beyond the reach of maps, signs, and guidebooks. None of us can ever know all the great natural places in Florida, much less travel there or even see pictures of them. And there is, I think, value in that realization. It means that we yet live in a state imbued with mystery, a place whose allure is larger than any of us can experience in a lifetime.

May adventure and serendipity be your guide as you seek to discover your own secret Florida.

The photograph was made with a 16mm full-frame fisheye lens on Fujichrome Velvia slide film from atop the 16-foot JohnnyPod ladder tripod. A two-stop graduated neutral density filter added density and contrast to the summer sky.

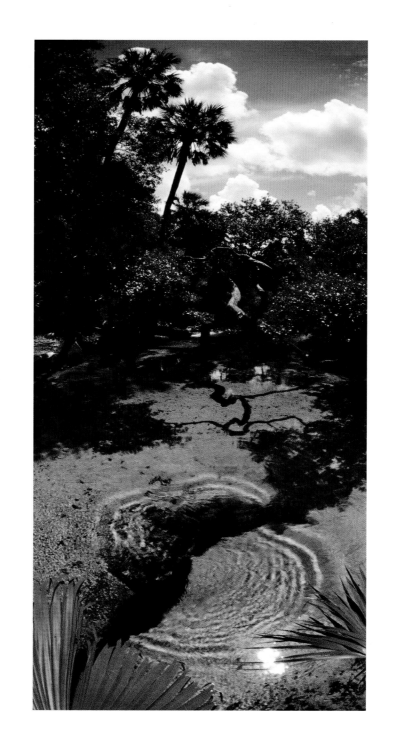

Eye of the Gator

Newnan's Lake, Alachua County, 1999

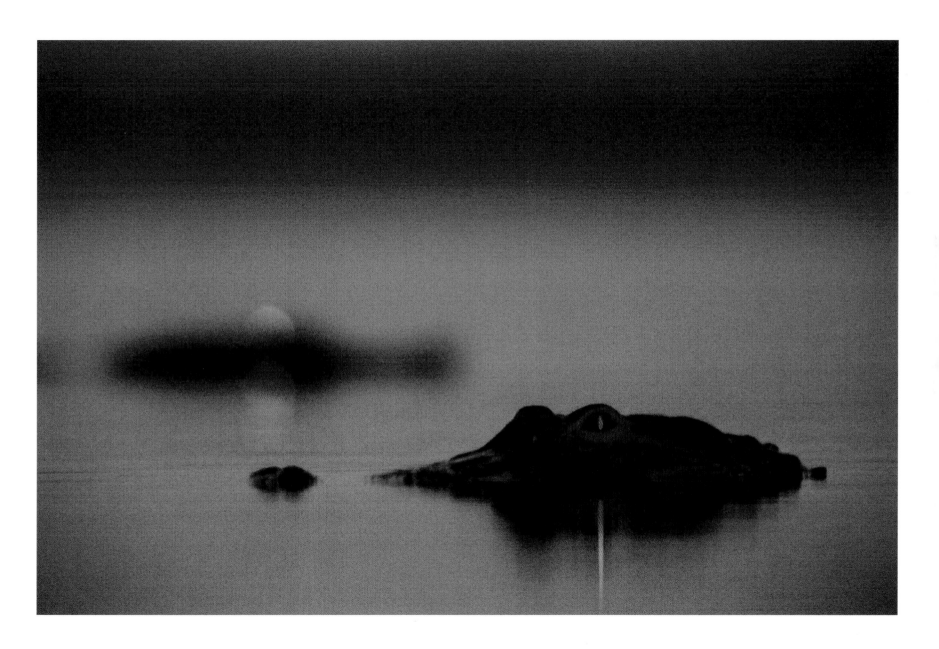

The Gifts of Two Men

Royal Mute Swans and Bok Tower Reflection, Historic Bok Sanctuary, Lake Wales, Polk County, 1998

Nature photography is fundamentally antisocial. Committees don't make pictures, and hanging out with a photographer in the field is often both a distraction to the photographer and no fun for the companion waiting for the photographer to "finish already with shooting that picture."

When concentrating on composing my nature photos, I ordinarily work alone. But on a book project to photograph Historic Bok Sanctuary in Lake Wales, I found that I carried a constant awareness of the gifts of two men, Edward Bok and Bill Maxwell.

In seven visits over three years, I had the keys to the kingdom in crawling and climbing all over what surely is one of America's great botanical treasures. Bok Tower and the surrounding gardens, sitting atop the highest point in peninsular Florida, was a gift to the American people from Edward Bok, a remarkable man who achieved notable success and wealth as a writer and editor in America after emigrating from the Netherlands in 1863 at the age of six.

Bok won the Pulitzer Prize for his autobiography in 1919, but is best known for his creation in 1929 of this magnificent garden, forty miles south of Orlando, which he envisioned as a "sanctuary for humans and birds." To bring to life his verdant dream, Bok commissioned landscape architect Frederick Law Olmsted Jr., son of the famed designer of New York's Central Park.

Soaring above the gardens is the "Singing Tower," as it is known, a two-hundred-foot-tall Gothic Revival masterpiece, visible for miles. Sculpted in Florida coquina and pink Georgia marble, the tower enshrines a fifty-seven-bell carillon that still tolls the hour. A daily afternoon recital bestows music both joyful and melancholic through the gardens below.

What would compel a man to create such a gift? Grateful for the success he achieved in America, Bok was inspired by the words of his Dutch grandmother: "Make you the world a bit better or more beautiful because you have lived in it."

This singular gift of one man stayed with me in my days of delight wandering the gardens, chasing after butterflies and bullfrogs, past azaleas and lilies.

I carried, too, an awareness of the gift of Bill Maxwell, a friend from his days in Gainesville, who went on to become a columnist for the *St. Petersburg Times*. Maxwell went to the gardens often to escape the intense culture of the newsroom, and was so moved by the beauty of his garden visits that he wrote a poem to express his experiences. He titled his piece, "Finding Yourself: A Spiritual Journey Through a Florida Garden."

I see a butterfly flittering from petal to petal.
I stand there, intrigued that this tiny creature can fill me with such wonder.
I want to touch its beauty, to experience its freedom.

~

I experience anew the real secret of Bok Tower Gardens:
its quietude, a spiritual presence that induces a feeling of contentment.

Response from readers of the *Times* was overwhelming, prompting a suggestion by Bok Sanctuary management to republish Maxwell's column in book form.

Maxwell's gift to me was two-fold: an invitation to create a body of photographs to illustrate the book and a sensitive poem to guide me in my task.

Alone with my cameras in this extraordinary garden, Bok's legacy was everywhere I looked, and Maxwell's gift was everywhere I went.

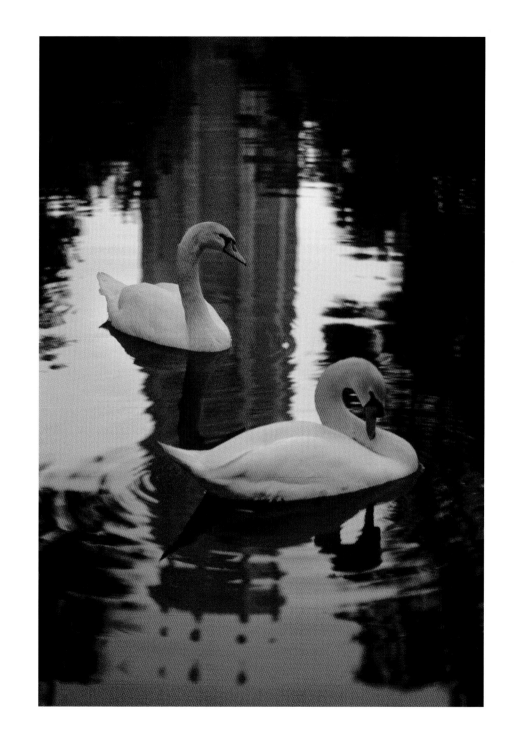

Hope for the Sacred River

Ichetucknee Springs State Park, Columbia County, 1993

Across cultures and spanning the millennia, we humans are hard-wired for aquatic seduction. Images of rivers permeate our art, music, literature, and religion. The water baptism ritual is at the heart of the Christian experience. Descriptions in the Qur'an depict heaven as being watered with flowing rivers. Among some indigenous peoples of Africa, spirits of the water are seen as the providers of knowledge and wisdom.

The ability of water to sustain and inspire us body and soul is seemingly inevitable, given that we live on a blue planet whose surface is seventy percent water and reside in bodies that were nurtured before birth in an amniotic sea and even now are sixty percent water.

Most of us can recount how the magic of water has shaped our personal stories of what it means to be a Floridian. Birthdays and reunions, weekends and holidays; again and again we are drawn to the water. Some were baptized at the river, and others, like myself, plan to have our remains scattered there. It gladdens me to know that in my final trip down the Ichetucknee, my ashes will intermingle with the turtles and fish of my favorite river, flowing onward to the sea.

At the end of each summer at my church in Gainesville, we join in the annual Gathering of the Waters ceremony to add vials of water from our travels to baptismal urns of water collectively signifying healing, peace, power, and homecoming. In our search for meaningful ritual to bring us together, water once again provides the bond.

Several years ago, one of our church members returned from a trip to the Middle East where he saw an Israeli television program on Florida's fabled Ichetucknee River, a program that marveled about this river sublime in a faraway place seemingly overflowing with freshwater.

But all is not well on the River of Life. We live to consume, or so our culture would have us believe, and water resources, historically viewed as limitless in Florida, are in notable decline and degradation. The recent five-year drought and the brewing intrastate water war scared up a few headlines, but the thirst of a growing state continues unabated, and surface water pollutants increasingly taint the source of our drinking water.

This point was driven home to me in May 2003 when I went to the Church of the Sacred River, as I like to call it, for my seventeenth consecutive Ichetucknee birthday on the river. Where once I swam through crystalline water, drifting past an emerald carpet of dancing eelgrass, those same aquatic grasses were now covered with a tough, thick coating of brown algae, and the water was cloudy and dull. The picture shown here, made ten years earlier, shows a healthy river I scarcely recognized. It seems the Ichetucknee, long regarded as Florida's most pristine river, is dying; dying a slow death of a thousand cuts as its recharge basin fills with people and their detritus.

How can this be? The declining state of the Ichetucknee is emblematic of a larger disconnect we have with the natural world that has sustained us so well for so long with gifts that have demanded nothing in the way of spiritual or material recompense. Ultimately, of course, there is a price to be paid, and the due date approaches.

But rivers, like people, have both a source and a destination, and stories to be told along the way. And this story isn't over yet. Am I optimistic for the fate of Florida's rivers and springs? I'd prefer not to answer that question. Let me say instead that I do have hope. Hope, the great sustainer, which gives us cause to toil on in spite of daunting odds. Hope that our culture can learn to honor the sacred in nature. Hope that we choose political leaders who understand that we are a part of the Earth, and not apart from it. Hope that the River of Life leads us to a deeper understanding and appreciation of the waters that sustain us and call on us now to act on their behalf.

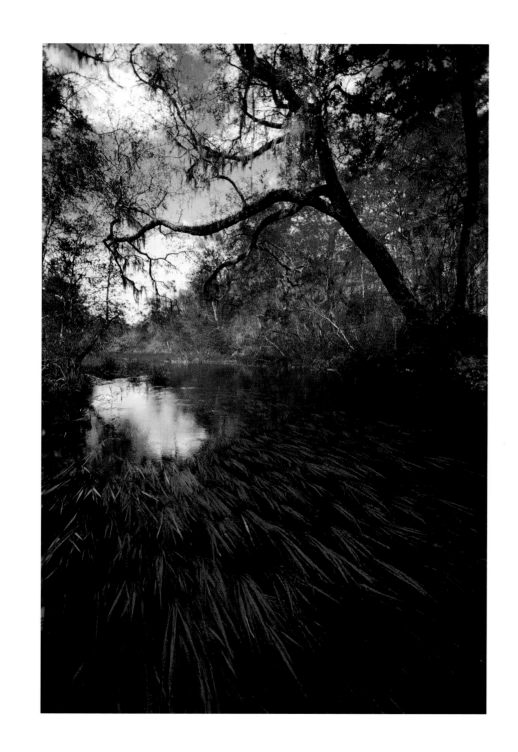

Going Home

Loggerhead Sea Turtle Tracks, Archie Carr National Wildlife Refuge, Brevard County, 1989

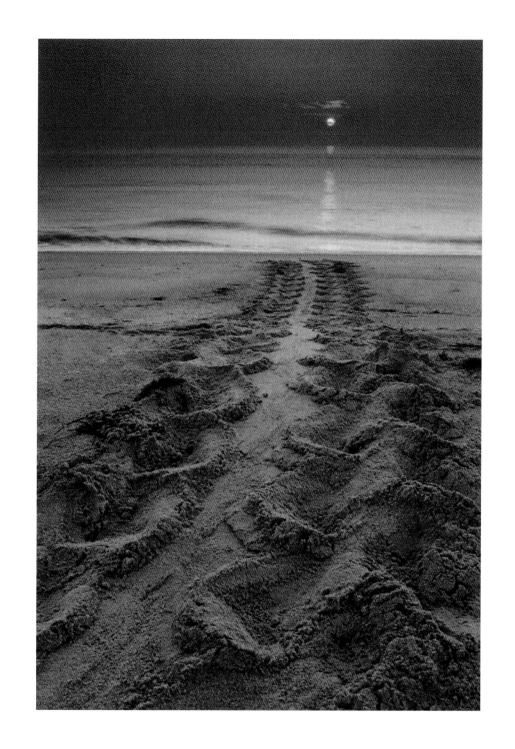

John Moran's portfolio of landscape and wildlife photography ranges from the Gulf to the Atlantic, with an emphasis on Florida waters: the rivers, coasts, swamps, lakes, and springs, and the creatures that inhabit them.

Following a twenty-three-year career as a photographer, writer, and editor for the *Gainesville Sun*, Moran left the world of daily journalism in 2003 to photograph full time the best of vanishing natural Florida. A University of Florida graduate, Moran's photography has been published in numerous books and magazines including *National Geographic, Life, Time, Newsweek, Smithsonian,* the *New York Times Magazine* and on the cover of the *National Audubon Society Field Guide to Florida.*

Moran has been named Photographer of the Year for the Southeastern United States by the National Press Photographers Association. In 1990, he received major grants from the Florida Humanities Council and The New York Times Company Foundation to create a photo exhibit on the Suwannee River, entitled *Florida's Grand Old River: A Photographic Essay on the Suwannee,* which continues to tour the state.

View John Moran's work on his Web site: www.johnmoranphoto.com.

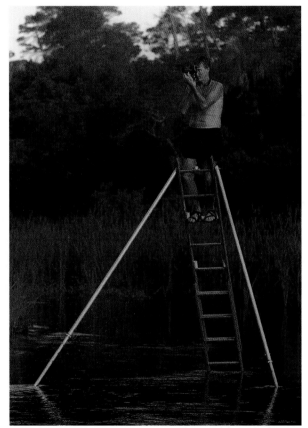

Photograph by Michael Kooren

Acknowledgments

This modest volume would take on the look and heft of a phone book were I to properly acknowledge the many people who have helped me on my path during the many years it took to create this body of work.

I begin by honoring the memory of my parents, Jack and Martha Moran, for their wisdom and sacrifice in planting me where I could thrive. I thank my wife, Peggy Bowie, and our daughters, Alexis and Caitlin, for their patience and love, and for trusting my instincts.

I am grateful for the support of my friends and former coworkers at the *Gainesville Sun,* including publisher Jim Doughton, executive editor Jim Osteen, managing editor Jacki Levine, features editors Jeff Tudeen and Lillian Castro, design editor Rob Mack, and former photo editors Tom Kennedy, Gary Wolfson, Tim Davis, and Dede Smith. The *Sun* was my professional and creative home for more than 20 years, and most of the pictures and essays published here first appeared in the pages of the *Sun.* Thanks, too, to the many fine *Sun* staffers who made leaving the world of daily journalism all the more difficult. It is the job of a newspaper photographer to serve as a visual historian for the community, and it was my great privilege to serve in that capacity for all those many readers who gave to me more than they can know.

I give thanks to University Press of Florida, and notably to Meredith Morris-Babb, Susan Albury, Lynn Werts, Nevil Parker, Jim Denton, Andrea Dzavik, Nicole Sorenson, and Larry Leshan, for their high level of professionalism in helping me through the challenges of birthing this book.

Special thanks are due Jim Trebilcock, whose tireless support has redefined the meaning of friendship in my life.

Those who call Florida home can be proud that many of the pictures were made in Florida state parks (notably Paynes Prairie Preserve State Park and Ichetucknee Springs State Park), whose management and staff maintain and develop what is broadly acknowledged as a national model of natural resource management.

In addition to the individuals and organizations directly mentioned in the essays, I would be remiss if I failed to mention the assistance and support of the Florida Department of Environmental Protection, Florida Fish and Wildlife Conservation Commission, U.S. Fish and Wildlife Service, National Park Service, U.S. Forest Service, Florida Museum of Natural History, Suwannee River Water Management District, St. Johns River Water Management District, Florida Humanities Council, The New York Times Company Foundation, Recreational Resource Management, Ginnie Springs Outdoors, Blue Springs-Santa Fe River, Historic Bok Sanctuary, City of Gainesville Morningside Nature Center, Alachua County Poe Springs Park, St. Augustine Alligator Farm, Camp Kulaqua, Nikon Professional Services, Fuji Photofilm USA, Digital Technology Group, Flair Pro Photo Lab, Harmon's Photo, Imagers of Atlanta, Biomedical Media Services, Gulf Atlantic Airways, George Tortorelli, Tom Morris, Stephen Williams, Allen Brasington, Barbara Plourde, Bill Belleville, Harold Martin, Carla Hotvedt, Tom Blagden, Bill Fortney, Scott Robinson, Bill and Lois Ploss, Anthony Ackrill, Lars Andersen, Michael Weimar, Bob Stoner, Phil Yountz, Rad Hazen, Allen Baxley, Lisa Andrews, Gene Bednarek, Dennis Masterson, Trude Spillane, Alvaro Ortiz, Dan Rountree, Steve Earl, Larry Johnson, Jon Fletcher, Dave Wieffenbach, Jeff Ripple, Ollie Huff, Jeff Wade, Bruce Ferguson, Colleen Castille, Bill and Belle Mathews, Pat Murphy-Racey, Billy Dean, Lee Malis, Rob Mattson, Jack Gillen, Jim Weimer, Pete and Bette Walker, Jeana Brunson, Steve Vaughn, Alex Smith, Chris Tubbs, Alan Youngblood, Annie Dillard, Warren Nielsen, Sally Morrison, Jack Ross, Kaye Richardson, Al Diaz, Jim Stevenson, Michael Gannon, Charlotte Porter, Bruce Day, Randy Batista, John Lopinot, June Cussen, Bill DeYoung, Paul Moler, David Hackett, Mike Gough, Steve Pruitt, Phil and Dorothy Baker, Wes Skiles, Mac Stone, Steve Everett, Mark Barrow, Jim Valentine, Jim Atyeo, Mitchell Jim, Jeff Sterling, Hobart Swiggett, Stephen Bourdon,

Woody Woodward, Penny Wheat, David Price, Lauren Day, Lew Ehrhardt, Star Bradbury, Ron Ceryak, Bill Frakes, Clay Henderson, Dick Bowles, Chuck and Ann Bruning, Stuart Bauer, Bill Sargent, Bruce Means, Sue Wagner, Bill Maxwell, Al Burt, Mike Bullock, Linda Crider, John Kaplan, Don Goodman, Cyle Sage, Azell Nail, Tom Brown, Gil and Pamela Minor, Vic Spangler, James Asbell, Jim Gordon, Ron and Julie Matus, Mark Smith, David Beede, Buster O'Connor, Bill Feaster, Robert Seidler, Richard Orsini, Wendy Spencer, Gail Soucy, Perry McGriff, Howard Adams, Allen Cheuvront, Pegeen Hanrahan, Rob Deese, Stephen Morton, Hoch and Celeste Shitama, Rex Rowan, Gary Appelson, Bruce Morgan, Greg Bruno, Kate Barnes, Scott Erickson, Jerry Uelsmann, Patrick Grigsby, Jan Walden, Bruce Dale, Steve Nesbitt, Joe Piazza, Butch Baker, Valerie Rivers, Chip Sawyer, Margaret Tolbert, Andrei Sourakov, Mike Willson, Chris Nikdel, Fred Parrish, Evon Streetman, Harley Means, Pam McVety, Cathy Puckett, Brent Williams, Kevin Conlin, Bob Self, Rich Parenteau, John Schert, Bob Simons, Greg Lepera, David Greenbaum, Charlie Houder, Martha Nelson, Lou Guillette, Zach and Linda Neece, John J. Morgan, Karekin Goekjian, Bruce Delaney, David Webb, Jeff Klinkenberg, Kent Vliet, Virginia Seacrist, Tommy Thompson, Cathy and Allen Cox, Yvonne Trebilcock, Michael Kooren, Steve Robitaille, Bruce Ritchie, Cameron Gillie, Richard Hamann, Leslie Gaines, Doug Cavanah, Bron Taylor, Kevin Sparkman, Johnny Horne, Bill Hammond, Jack Putz, Robert Hutchinson, Frank Orser, Steve Lord, Mike Loomis, Brian Ainsworth, Jim Lloyd, Dale Crider, Bill Rohan, and the late, great Marjorie and Archie Carr. Thanks to Sandy and Larry Reimer of United Church of Gainesville, whose spiritual insights helped me see and appreciate the Big Picture. And thanks to all of my wonderful patrons across Florida, whose support makes it possible for me to feed my family as I feed my soul.

Copyright 2004 by John Moran
Printed in China on acid-free paper
All rights reserved

09 08 07 06 05 04 6 5 4 3 2 1

Library of Congress Cataloging-in-Publication Data
Moran, John, 1955–
Journal of light : the visual diary of a Florida nature photographer / by John Moran.
p. cm.
ISBN 0-8130-2772-1 (cloth : alk. paper)
1. Nature photography—Florida. 2. Natural areas—Florida—Pictorial works.
3. Florida—Pictorial works. I. Title.
TR721.M68 2004
778.9'43'09759—dc22 2004052038

Some of the essays and photographs reproduced with permission from the *Gainesville Sun* Newspapers, Inc., and the *New York Times*, Inc. Their generosity is gratefully appreciated.

The University Press of Florida is the scholarly publishing agency for the State University System of Florida, comprising Florida A&M University, Florida Atlantic University, Florida Gulf Coast University, Florida International University, Florida State University, University of Central Florida, University of Florida, University of North Florida, University of South Florida, and University of West Florida.

University Press of Florida
15 Northwest 15th Street
Gainesville, FL 32611-2079
http://www.upf.com